Sign Painting
and
Graphics Course

Sign Painting and Graphics Course

Lonnie Tettaton

Nelson-Hall nh Chicago

Library of Congress Cataloging in Publication Data

Tettaton, Lonnie.
 Sign painting and graphics course.

 Includes index.
 1. Sign painting. I. Title.
TT360.T45 745.6′1 80-12135
ISBN 0–88229–478–4 (cloth)
ISBN 0–88229–768–6 (paper)

Reprinted 1983, 1984, 1987

Manufactured in the United States of America

10 9 8 7 6 5 4

Contents

Introduction

The sign business is changing. It's becoming more sophisticated as it is influenced by zoning laws and sign restrictions in various municipalities. The large, spectacular signs, for the most part, are being controlled.

Signs now are designed to fit the environment or to conform with the architecture of a building with which the sign is associated. Some signs are designed into the construction of the building.

This book will deal with all the types of signs shown in illustration I.1. The small sign with clean lines and a graphic look is growing more popular. Sign materials are durable and permanent, such as plastic, aluminum, and duroply (wood); some have special surfaces such as baked enamel.

Newer signs exhibit a variety of materials and techniques: wooden plaque displays, sandblasted to appear three-dimensional, and hand-carved routed signs; wood and plastic cut-out letters; and illuminated plastic signs with plenty of air space around the copy are some examples.

Symbols and logos are used on signs because of their clean design and conservation of space. Large corporations use logos for identification to replace spelling out their names. Getting more copy in less space helps the advertising dollar go further, and signs along roadways must be readable in the short time it takes to drive past them.

The sign business is changing in other ways—it is changing its image to gain more respect from city planners and governments, architects, and the general public, who do not realize the important role signs play in their community. As part of the effort to change the image of the business, new terminology replaces the word "sign." Some examples are: communications device; street display; graphics; visual advertising; advertising; outdoor advertising; lettering; displays; and display art.

Accuracy and consistency in letter construction cannot be over-emphasized. At first, this will be difficult to achieve. With continued practice, however, you will show visible improvement.

I.1 These examples of the author's work are found in the St. Louis metropolitan area. Notice how various signs are presented in an harmonious, attention-getting fashion.

As you become more skilled, you may find that you are more comfortable using a sequence of strokes different from that taught here to construct your letters. This is a normal tendency. You should, however, begin your practice of each new letter or alphabet with the straight lines and progress to the curves. Following this sequence and mastering each component stroke of a letter will help you gain the confidence you need.

Keep this book at your side during your preliminary work. Think of it as an instructor, always ready to assist you when you encounter difficulty during your practice. When you are satisfied with your mastery of the straight and curved strokes, try a complete letter without referring to the book. Repeat this procedure throughout the entire alphabet, referring to the book only after you have completed a group of letters that you consider to be acceptable. Use the same procedures for words and sentences. This is a difficult task. But remember: all craftspeople have undergone the same training period, whether in school, on the job, or at home. Remember that they are craftspeople because they had the interest and willingness to work towards perfection.

At first, don't make your practice periods too long. You may find that lettering, being a new activity for you, causes you to tire rapidly. Begin by working for a short time—about forty-five minutes. As you gain skill and confidence, you'll be able to work for longer periods without mental or physical fatigue.

A skilled commercial sign painter will find many opportunities in areas such as:

Outdoor Advertising
Graphic Design
Silk Screen Printing
Displays
Neon and Plastic Signs
Show Cards

Each of these is a separate field. Some small commercial shops produce a few of each kind of sign. Other shops may specialize in truck lettering, for instance, and do a show card or display only occasionally.

Illustration I.2 gives a breakdown of the six areas of the sign business, each of which contains more specialties. It seems there is no

end to the variety of work a sign painter may do. Most painters concentrate on the type of work they do best and most efficiently.

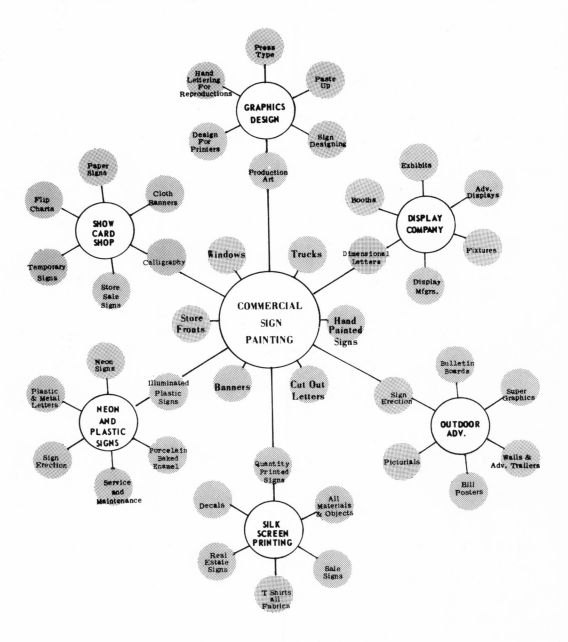

I.2 Major areas of the sign business.

Section 1

THE importance of good tools cannot be overstressed. Without them, it is impossible to become a true craftsperson. Poor quality tools will result in poor quality lettering, no matter how much practice a person does and regardless of a person's talent. Although different jobs may require different types of brushes, paints, and materials, these tools always should be of the highest quality you can afford.

Brushes for Lettering Signs

Red sable brushes are generally used for the application of all water-based paints to smooth surfaces. These brushes are used because they maintain their body or stiffness and the bristles hold together well when wet. If you attempt to use soft brushes, such as red sable, on a rough surface, you will find it impossible to achieve a smooth, even application of paint since the soft bristles will tend to ride over or around the surface irregularities. In addition, the rough surface will quickly ruin your good brushes.

Because of their consistency and flowing characteristics, oil-based paints and enamels permit the use of softer brushes, even on semi-rough surfaces. Brushes generally used with these mediums include the *camel hair, gray squirrel hair,* and the common *quill* type. When oil-based paints are to be applied to materials having a rough surface, special types of brushes having very stiff, pure white *wild boar* bristles are used. These are called *cutters* or *fitches*. (See illustration 1.1.)

A *flat* is a flat brush with medium-length ox hair bristles. It is particularly useful in maintaining an even width of stroke on curves. This brush is called a flat because, when used, it is pressed flat to its full width. Flats are used with oil-based paints on smooth and semi-rough surfaces, usually on letters over six inches high. Quill brushes are used with oil-based paints on smooth surfaces. Only the tip of the quill brush is used.

The large brush at the top right of illustration 1.2 is a short-handled 1 inch *black ox hair muslin* brush (sometimes called a *black sable poster* brush). It has a brass ferrule, a band to keep the wooden handle from splitting. The ¾ inch size is also handy. It can be used for all kinds of large lettering or filling in backgrounds.

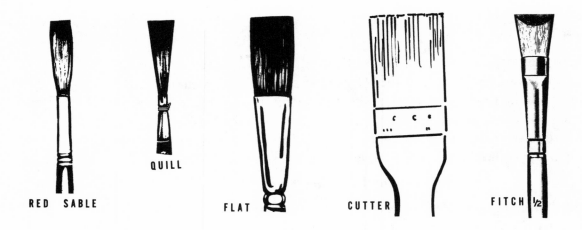

RED SABLE QUILL FLAT CUTTER FITCH ½

1.1 Brushes for water- and oil-based paints.

The gray camel hair and gray squirrel quills, sizes 3, 8, and 12, are used most often. They are fitted with wood handles and come in many sizes. For large work, a jumbo no. 20, as shown here, is good.

Do not be confused by the great number of flat lettering brushes listed in the supply catalogs. Some of them are all right, but many of them are of little use to the average sign letterer. Buy single brushes instead of sets, until you find which kind you use best.

The two lower illustrations in illustration 1.2 are greatly reduced from actual size. The one marked with the letter "S" is a sable hair *water size* brush, used to apply size (glue-like material) on the inside of glass for gold leaf, palladium, and silver leaf window signs. The

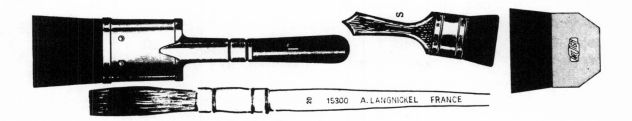

1.2 Brushes for painting large areas and for size application.

bottom illustration is a gilding tip used for picking up the leaf and laying it on the glass, as explained in Section 4 in the sub-section on gold leaf.

For outdoor work, bulletin boards, and large storefronts, soft-haired fitches are used instead of bristle fitches. The soft-haired fitches come in two categories: the 1½ inch pure bristle cutter—used for cutting and filling in letters, and the outdoor brushes—the 1 inch, 2 inch, and 3 inch cutters, and a 4 inch filler.

Rollers are used a great deal for coating out signs and sign material. The term coating out applies to painting the surface of any material you are to letter on (preparing the surface for lettering). For example, an existing sign may be coated out so a new sign can be painted on the same surface. A good grade mohair roller is the one most used. Some of the cheaper throw-away rollers leave lint and fiber on the surface you are coating. Larger Knap rollers (sheepskin) work best on porous surfaces such as brick. If you have one small sign to coat out, you can use a cutter.

Care of Brushes

Don't use the same brushes for oil-based paint and water-based paint. They are different kinds of paint and you will ruin your brushes.

After using a brush in water-based paint it may be washed with regular hand soap, rinsed out well, and smoothed to its natural shape using your fingertips with very slight pressure.

After using a brush in oil-based paint it should be rinsed in lacquer thinner; work the paint out of the heel of the brush gently with your fingertips. Avoid pulling the hairs. Dip the brush in brush oil and smooth it out gently with your fingertips; lay the brush flat when it is not in use. A metal tray is ideal for holding your brushes.

To make brush oil, you may use lard oil or motor oil and mineral spirits mixed in equal parts. The brush oil keeps brushes from drying out. The oil must be rinsed from the brush with lacquer thinner before each use.

Avoid letting paint dry in your brush or leaving it in a container of paint or thinner. You may return for your brush within an hour and find that the bristles are set in a curved position and you are not able to straighten them.

Paints and Thinners

Lettering colors (enamel) are used for small commercial work: trucks, windows, and board signs. They can be used on wood, metal, glass, plastic, and all painted surfaces. They work best when thinned with turpentine. Lettering colors have heavy pigments. The colors are strong for good coverage and work well with the lettering quill. The varnish content in this paint gives it a glossy finish and makes it durable.

Oil-based poster paints are waterproof and dry quickly. They are used for temporary and interior signs, such as show cards and displays. They dry quicker than lettering colors. Poster paints have a flat, no-shine finish; they contain more pigment and very little varnish. Flat finish paints are preferable when doing interior work to prevent glare from lights. Brushes used for oil-based poster paint are quills, flats, cutters, and fitches.

Water-based poster color is used by show card writers because it is economical and dries quickly. Red sable brushes are used for water-based poster color.

Oil-based bulletin colors are used for large commercial signs and all large outdoor signs, such as large storefronts, bulletin boards, and wall signs. Bulletin colors can be thinned with mineral spirits or oleum, which are more economical to use than turpentine. Turpentine may be used as a thinner, however. Bulletin colors can be brushed, rolled, or sprayed.

Flat blockout white is a flat, oil-based paint used for priming raw wood, duroply, and masonry surfaces such as brick and concrete block. Blockout white also is used for coating out existing signs. It is thinned with mineral spirits, oleum, or turpentine and used as a primer over existing signs that are to be repainted. Without priming, the old letters "bleed" through the new sign and can be seen. The flat white primer provides a good, no-bleed working surface.

Brush Strokes

Illustration 1.3 gives typical examples of stroke construction of the letters S, N, and O. Note that the brush should move in long, flowing strokes. Also shown in this illustration is the method of using a double stroke to achieve a smooth, even letter.

When making a straight brush stroke, try to end the stroke with a

tip-out, a slight snap of the brush at the end of the stroke to give the letter a crisp, definite appearance.

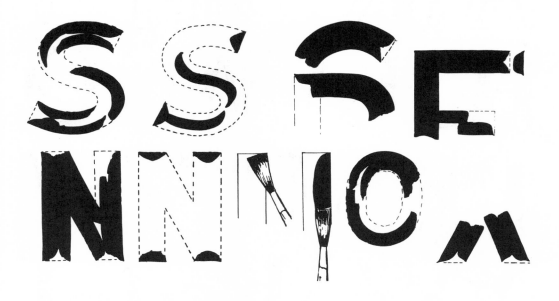

1.3 Some common brush strokes.

Illustration 1.4 shows the brush strokes of a thick-and-thin alphabet. First the letter is outlined; then the outline is filled in with solid color.

Learn to use the correct amount of paint with your brush. It is not possible to cite one drop, or two, or ten, or any specific quantity as the correct amount to load on your brush. This varies with your ability, the type and quality of your brush, the type of paint you use, and what you are painting. As you practice, try to use as much paint on your brush as possible without producing drips or runs. With practice you will learn just the right amount of paint for good coverage.

When you apply the paint to the work surface, try to achieve a smooth, flowing stroke. On curved strokes, try to make the stroke with one motion. This will enable you to get maximum coverage from each paint load. The less you have to stop and reload the brush, the faster your work will progress and the smoother your letters will be.

ABCDEFG
HJKLMNO
PRSTUVW
XYZabcdef
ghijklmnop
qrstuvwxyz

1.4 Outline, then fill in the letters.

Speedball Pens

The round point Speedball Flicker pens are a great improvement over the old-style lettering pens. They do better work and last longer because the ink retainer opens up so that the pen is easy to clean.

You can get them in any art supply store, and they are fine for show card work. I prefer Higgins Waterproof Black Drawing Ink, but other inks can be used.

Material for Show Cards, Displays, and Interior Signs

Show card board, illustration board, foam core board, and upsom board are all lightweight and easy to cut and work with. Masonite is used in display when a more durable sign is required.

Standard size for show card and illustration board is 28 inches by 44 inches. Standard sizes for foam core are 2 feet by 3 feet and 4 feet by 8 feet.

White poster paper or drug bond is used for temporary signs and for patterns for plastic signs. Drug bond is a wrapping paper usually thinner than poster paper; it comes in 3-foot and 4-foot rolls. It can also be used for tracing signs.

Brown Kraft paper is used for large patterns and for patterns that are to be used many times. The brown paper is more durable than poster paper. Kraft paper has the color of a brown paper bag, it comes in rolls 3 feet or 4 feet wide, and is used for wrapping paper.

Material for Exterior Signs

Masonite or plain plywood is not good for permanent signs. They are used primarily for temporary signs such as real estate signs. When using masonite (hardboard), prime the front and back with flat blockout white. Duroply or crezon are materials that are ideal for most board signs. They are plywood-type materials with a smooth lamination on one or both sides. This lamination becomes a part of the board and will not crack or peel when used outdoors.

The best material for permanent signs is aluminum with a white, baked-enamel finish. Most aluminum supply houses carry precoated aluminum in 4-foot and 10-foot sheets. If you use aluminum that is not coated, it must be primed with zinc chromate primer, then coated with the color you require.

When using sheet metal, prime both sides with an oil-based metal primer (preferably white) in order for your lettering colors to cover well.

The Beugler Striper

The Beugler Striper (illustration 1.5) is good for striping trucks and pleasure cars, making straight borders on signs and panels, and putting a decorative stripe through letters. Lettering or bulletin colors are perfect for use in the Striper, just as they come from the can. Keep the Striper standing in a small can of turpentine, along with the extra wheel. Clean it with a rag before using.

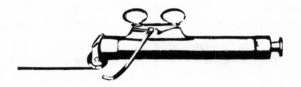

1.5 The Beugler Striper.

Using a Maulstick

If you have ever watched a sign painter at work you may have noticed that the painter rests his hand on a baton-like piece of wood, which he moves as the work progresses. This piece of wood is a maulstick (illustration 1.6). We don't know how long painters have used such a guide, but its antiquity may be guessed from the fact that the original spelling, *maalstok*, was derived from the ancient Danish words *malen*, to paint, and *stok*, stick. Proper use of the maulstick requires time and patience, but the effort is well rewarded. You will find that it helps keep your free hand out of the way, while aiding you in the development of a smooth brush stroke.

For a practice maulstick, procure a piece of wooden dowel about one-half inch in diameter and 36 inches long. Slip a rubber furniture tip over each end. These rubber tips will elevate the stick so that it cannot touch the wet lettering, and they will prevent the stick from slipping.

Rest your brush hand on the stick, which is controlled by your free hand. This is shown in illustration 1.6.

Another way of using the maulstick is also shown in illustration 1.6. This method is normally used when constructing large letters—6 to 7 inches or higher. In this method your free hand lines the maulstick up parallel to the letter you are constructing. Hold the brush with the thumb and index finger and allow the remaining three fingers to slide down the stick the distance required for the desired stroke.

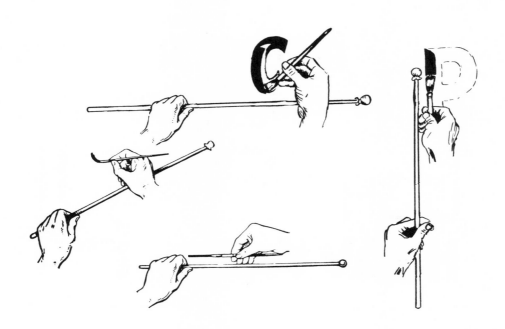

1.6 Using the maulstick.

Basic Lettering

First we'll examine the construction of Egyptian letters. The beginner should learn to render them with pen, pencil, and brush. Only a few simple rules apply to this construction, and they may be broken after you really know the letters and have mastered them.

All lines, or strokes, are of the same width or "weight." Normal Egyptian lettering usually is five to seven strokes high; this is called *heavy* Egyptian. If letters are eight to ten strokes high they are called *light* Egyptian, or Gothic (illustration 1.7a).

If the normal-size letters are five strokes high, they are about four strokes wide. The wide letters (A, M, O, Q, W) are about five strokes

wide. The five narrow letters (E, F, J, L, S) are about three strokes wide. The letter I occupies one-half of a normal letter space. Comparative letter widths are discussed later in the book.

A letter may be stretched to fill a space up to twice its normal width and still be readable. Such a letter is called *extended*. A letter may be squeezed into a space one-half its normal width. The resulting letter is called *condensed*. A condensed and an extended H are shown in illustration 1.7c.

EFJLS I N

AMOQW

b. Narrow and wide letters.

LIGHT

HEAVY

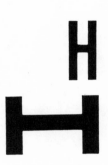

a. Heavy and light Egyptian.

c. Extended and condensed letters.

1.7 Basic lettering.

When you learn to extend or condense an alphabet, your lettering can be made to fit into almost any space desired.

Until you learn the rules and your eyes become accustomed to the proportions, measure the letters. Professional sign letterers often do this spacing freehand, without having to measure each letter. It is a knack which comes to you with practice.

Illustration 1.8 shows a set of Egyptian capitals. Measure the individual letters to study and construct them. Besides the five wide letters (A, M, O, Q, W), the C, G, and V are a little wider than normal letter size. Carefully make a pencil copy of one of the Egyptian alphabets in order to memorize the proper letter shapes. The following four pages discuss and show examples of the structuring of the letters.

A B C D E

F G H I J K

L M N O P

Q R S T U

V W X Y Z

1.8 Egyptian capitals.

Compare the two examples of the word PACK in illustration 1.9.

Poor: The vertical strokes are not perpendicular to the baseline, the straight strokes are not straight, the curved strokes do not follow the letter form, and the width of the strokes is not uniform. In addition, the spacing is poor.

Improved: Note how eliminating the faults discussed in the previous example makes the word appear as a unit instead of as individual letters strung together. This lettering has a much more professional appearance.

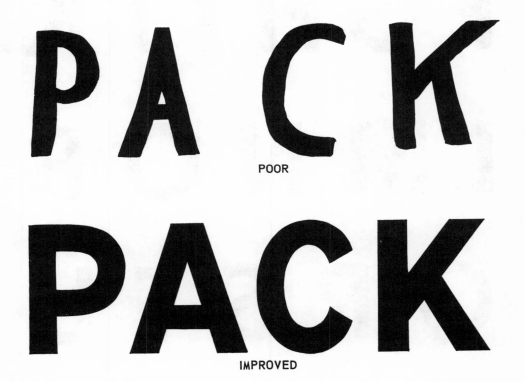

POOR

IMPROVED

1.9 Straight lines and proper spacing are important.

Contructing the Basic (Egyptian) Alphabet

All alphabets are modifications of the basic Egyptian alphabet (see illustration 1.10). If you do not master the basic alphabet, you will be unable to become skillful at those that follow.

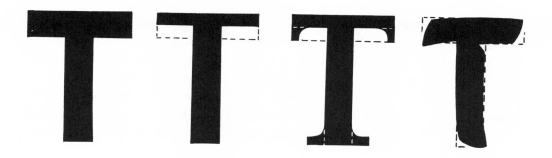

1.10 Modifying the basic Egyptian letters.

A: The top stroke of the letter A should be only slightly wider than the two diagonal strokes. Thus, top-heaviness is avoided and the letter has a more balanced appearance. Note also that the horizontal center stroke is placed midway in the open area between the diagonal strokes.

B: The rounded strokes of the B must flow smoothly into the horizontal center stroke. The center stroke should be a hairline thinner than the vertical. As a base upon which the letter rests, the bottom half of the B will seem more balanced and pleasing to the eye if it is extended out slightly more than the top half.

C: The letter C may be thought of as a circle with a portion of one side deleted. This letter is best constructed by dividing the space where it is to be inserted into four equal areas. After completing the letter, compare both sides of the vertical and horizontal; they should be even.

D: The completed letter D should be checked for evenness of strokes and vertical balance. Do this by drawing a horizontal center line thru the letter. Then compare the upper and lower halves.

E: When constructing the letter E, keep the horizontal center stroke slightly above midpoint of the vertical strokes to achieve visual balance. The horizontal center stroke should be slightly shorter than the top and bottom horizontal strokes. The three horizontal strokes of this letter should be a hairline thinner than the vertical stroke.

F: The letter F is constructed in the same manner as the letter E, except that the center horizontal stroke should be positioned slightly below midpoint of the vertical stroke. This will provide equal open space above and below the center stroke.

G: Like C, the G is an incomplete circle. In constructing this letter,

however, the bottom right curved stroke must extend out farther to the right than does the top right curved stroke. This is to accommodate the horizontal stroke. This horizontal stroke (sometimes called a bend-back) is located on the horizontal center line and extends left from the right bottom curved stroke to the vertical center line. All strokes of this letter are of the same thickness.

H: The letter H is composed of three strokes—two vertical and one horizontal. The horizontal stroke is slightly thinner than the vertical strokes, and is centered to provide an equal amount of open area above and below it.

J: When constructing the letter J, maintain uniformity of width on the curved bottom stroke. This stroke should be curved upward to a point where the inner surface would again become a vertical line if continued. Study the example carefully.

K: The letter K is another example of the use of a base effect to achieve a balanced appearance. In this case, the lower diagonal stroke should end slightly to the right of the upper diagonal stroke.

L: Note that the horizontal stroke of the letter L is only slightly more than half the length of the vertical stroke.

M: In the letter M, the middle diagonal strokes are brought to a point touching the base line in the middle of the open area between the two vertical strokes. In constructing this letter, particular care should be exercised to maintain uniform stroke thickness to avoid an unbalanced appearance.

N: The strokes required in the construction of the N are similar to those used in the M, except that the diagonal stroke should be a hairline thinner than the vertical strokes.

O: The oval configuration of the letter O is generally used in preference to the circular configuration. Usually this is done to produce a more eye-pleasing appearance, but it also may be dictated by space limitations. In constructing this letter, divide the letter space into four equal parts. Measure the width of your strokes, mark this width at four points, then flow the strokes into each other smoothly.

P: The letter P may be considered as the upper half of the B, except that the curved stroke flows back into the vertical slightly below the center of the vertical. Compare the two letters to see the difference in proportion.

Q: The letter Q is constructed in the same manner as the O, with a short diagonal stroke extending through the lower right portion of the oval.

R: Further application of the principle of visual balance is found in the letter R. This letter is constructed in a manner similar to that used for the letter P, with the stroke forming the right leg falling roughly in line with the top left corner of the letter and extending slightly to the right of the top.

S: You may find that the letter S is one of the most difficult to construct properly. Probably the best way to begin is to take the width of your stroke and place this reference at the approximate positions shown by the white dots on the sample. Careful use of a smooth, flowing motion will result in an attractive letter.

U: The letter U is similar to the oval O. The construction of this letter may follow the same steps, with the verticals ending at the top guideline.

V: The letter V may be thought of, and constructed as, an inverted letter A, without the center horizontal stroke; a point should be formed where horizontals meet the diagonal.

W: Upon first glance, the W may seem to be nothing more than an inverted M. However, this is not the case. The W should be constructed as a pair of V's with the adjoining strokes overlapped at the top. Care in measurement is required to achieve good construction of the W.

X: In constructing the X, the two diagonal strokes should intersect slightly above the vertical centerpoint of the letter.

Y: The vertical center stroke of the Y meets the two diagonal strokes at a point slightly below the vertical centerpoint of the letter.

Z: The diagonal stroke of Z should rise at an angle of approximately 45 degrees. The upper and lower horizontal strokes should extend to, but not beyond, the upper and lower ends of the diagonal stroke.

Pages 18-21 illustrate the construction of the entire Egyptian alphabet.

G H I

J K L

M N

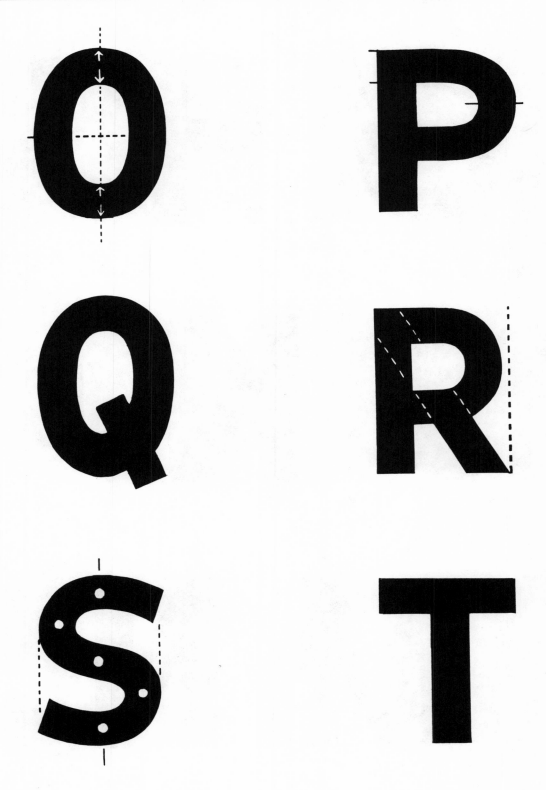

U V

W

X Y Z

Gas Pipe Letters

The condensed Gothic is also known as the "gas pipe" letter (see illustration 1.11). By using the stroke width of the letter you can mark the measurement on a yardstick and use it for the space between vertical strokes (as in D, H, N, etc.) and between letters. The stroke width of a common letter can be used as space between words. The "gas pipe" alphabet is one of the few lettering styles that can be done mechanically, with some variation in spacing. These exceptions are A, L, T, V, W, and X. (See the following section on *Spacing*.)

The gas pipe lettering style can be used for many signs. It works especially well on letters larger than average, for instance 10-foot-high letters. It is difficult to make an oval-shaped O or an Egyptian S in larger-than-average letters.

Gas pipe lettering can be modified for more creative lettering styles. For instance, you can fill more space on your layout with fewer words by making vertical strokes two strokes wide (see illustration 1.12).

Letter Size

The letters in the alphabet are not the same width or size. It is important to develop a sense of proportional letter width so that your completed work will be pleasing to the eye.

Illustration 1.13 shows an example of the application of this sense of size. Although the width of the letters varies from narrow in the top row, through medium, to wide in the bottom row, the width relationship between letters of the same range is maintained from row to row.

Because of the various combinations of straight, curved, vertical, diagonal, and horizontal strokes used in letter construction, it is not practical to use a fixed amount of space between each letter. To do so causes the letters to present an out-of-balance appearance. Illustrations 1.16, 1.17, and 1.18 show various combinations of letters, the correct amounts of space, and why certain spacings are correct or incorrect.

Spacing

Most beginners have a tendency to space letters with straight vertical strokes too close together. The width of a normal letter stroke or more should be left between letters with straight vertical strokes.

In the first example (a) in illustration 1.14 we see that all the letters of the word SALT are the same width and that the spacing has a mechanical regularity. Notice how small the letter A seems, spaced as it is between the letters S and L. Also note that there seems to be too much space between the letters L and T.

STROKE WIDTH

ABCDEF
GHIJKLM
NOPQRST
UVWXYZ

1.11 Condensed Gothic is also known as the "gas pipe" alphabet.

In the second example (b) we see that the width and spacing of the letters have been adjusted to their proper relationship. Notice the increased visual balance and pleasing appearance of this example.

The third example (c) shows two more samples of adjusted letter

spacing. When a letter containing diagonal strokes falls beside one with a vertical stroke, the most effective spacing is one-half the average stroke width. The word TAKE is a good example of this. The bottom of the right diagonal of the A should begin this distance from the vertical stroke of the K. This is also true of the spacing between the A and H in HAVE as well as between the V and E.

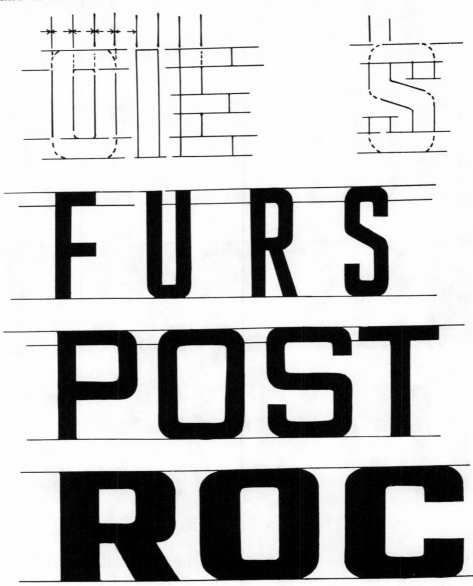

1.12 Gas pipe lettering can be modified for more creative styles.

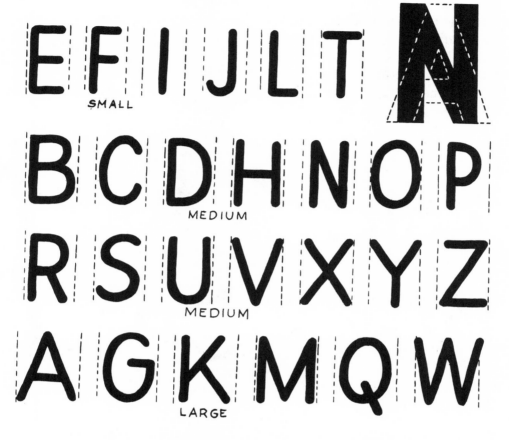

1.13 The letters of the alphabet are not all the same width.

In the case of the T and A in TAKE, a slightly different adjustment is needed. The left diagonal of the A has no counterpart from the T at the baseline. In order to achieve visual balance, the letters overlap slightly into each other's space. This is also true when the two adjacent letters contain diagonals on the same angle. The A and V in HAVE are examples of complementary angles which call for a slight overlapping into each other's space.

The word LAW (illustration 1.15) presents another problem. While the A and W have complementary angles, the L-A combination creates a large open space. To achieve visual balance and a unified effect, the L and A should almost touch at the baseline.

The letter W is usually the widest letter in a word. It should extend

slightly farther into the area of any adjacent letter containing a complementary diagonal stroke or into the open space of an L. This will enhance the visual balance of the word.

If the sign is in a box, as shown in illustration 1.16, and the letters are vertical structures, an equal volume of water would fit in each of the spaces. The application of this principle of relative distance between letters is called "fluid spacing."

TAKE SALT

Incorrect spacing.

HAVE SALT

Correctly adjusted spacing.

1.14 The spacing of letters is important.

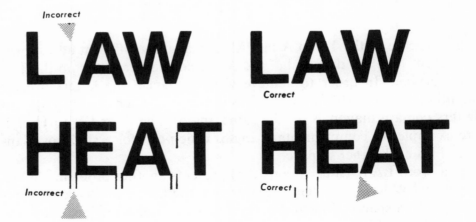

Incorrect

LAW LAW

Correct

HEAT HEAT

Incorrect *Correct*

1.15 To achieve visual balance, letters overlap into each other's space.

1.16 An example of "fluid spacing."

NATIO
NATIO
EN

1.17 Reverse lettering.

Reverse Lettering (Cutting In)

Reverse lettering creates a striking effect. Although at first glance you may assume that it will be a simple job of painting white lettering on a dark background color, such is not the case.

I normally begin with a light or white background work area. I first apply the lettering, using either light or white finish paint or enamel. Next I apply the dark background color, carefully painting around the edges of the letters and then filling in large open areas. Although this may seem to be backwards, I actually save time, effort, and paint. If I had applied the dark background color first, it would require at least two coats of white paint for the lettering, and an equivalent doubled requirement of time and effort to achieve acceptable coverage. (See illustration 1.17.)

Lower Case Letters

The ability to letter in lower case is of great value. Presently there is a trend to use all lower case letters in signs. Lower case letters exist in numerous variations. Two styles are shown in illustration 1.18. Whatever styles you may choose, you may be sure that people are already accustomed to seeing them in everyday use. Practice this phase of lettering carefully.

Numerals

The principles of construction and spacing of numerals are the same as those for letters. As in the letters, the use of smooth, flowing, rounded strokes will add visual balance to numerals.

Study the numerals shown in illustration 1.19. Notice how the curved strokes of these numerals flow, even though they were drawn with a rough, sketchy line. Follow the arrows in the numbers with your eyes and note how the strokes seem to flow together in the numerals 3, 6, and 8.

One-Stroke Lettering

Try to keep your letters upright and the strokes of equal weight. Make your curved letters "go round" without flat places or clumsy breaks. The round letters require the most practice, and when you can make good single-stroke letters O and S you have accomplished the hardest part of lettering. Illustration 1.20 shows the directions of the brush strokes in forming these letters.

abcdefghijklmn
opqrstuvwxyz

abcdefghij
klmnopqr
stuvwxyz

abcdefghij
klmnopqrs
tuvwxyz &

abcdefghijklm
nopqrstuvwy
xz

1.18 Some lower case alphabets.

When the term *one-stroke lettering* is used, it doesn't necessarily mean that you make only one stroke, or pass, on each component of the letter. Usually the ends of the letters must be cleaned up and adjustments made on the letters with the brush. One stroke is theory for beginners, but it can be developed through practice and experience.

The care or carelessness you use in this early work usually determines whether you will be a first-class sign painter or just fourth-rate. Learn to see the flaws in your own work. Try to improve your work in some way with each drawing or sign job you do.

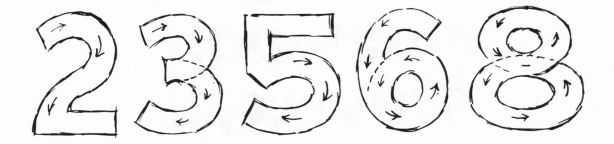

1234567890

2 3 5 6 8

1234567890¢

123456789
123456789
123456789

123456789
123456789
123456789

1.19 Numerals.

31

1.20 One-stroke lettering.

Section 2

Script Lettering

A MODERN trend in signs is toward script-style lettering. There always have been sign painters who could do good script lettering, but they did not do it as often as they should have.

A good piece of script lettering is especially attractive to the eye. It catches the eye and is easy to read. Signs with square letters often look too stiff even when the lettering is good. A word or two in script adds grace, swing, and the necessary curvature to make a good layout. Script can be used on almost any sign, from show cards to bulletins.

Many sign painters can do anything but script, mostly because they haven't tried it. They may be under the mistaken impression that they must have good handwriting to learn script lettering. In my files are letters written in longhand by the two best (in my estimation) script artists in the country. The handwriting is as bad as my own, perhaps even harder to read! One is a sign letterer and the other is a commercial artist and designer whose work has appeared in practically every big periodical in the country. It is hardly possible that you can write worse than they do, which proves that you can master script if you can do other kinds of lettering.

Script is really the easiest alphabet of all, for several reasons. We all learned to write in school, and any beginner knows this style better than the basic lettering types such as Roman and Gothic. You have more chance to modify the letters and express your own personality. The lettering does not usually have to follow an exact line, and there are fewer ends to square up. You can work with a free swing. If a letter happens to get half an inch off the guideline it may still be good—if it is graceful.

There are many who look on script as a mystery because most script signs do not follow any certain alphabet. That is, a letterer uses one kind of capital S (or some other letter) on one sign and an entirely different-looking capital on the next job. That also applies to lower case, though to a lesser degree. Anything is acceptable so long as it is graceful and in harmony with the other lettering.

A few simple aids may assist you; they can be forgotten after you master one good script style.

When you are learning script, the first thing you should do is draw the slanted lines. This will help you key all the letters on the same

slant. (After you are more experienced, you may not need these guidelines.)

Most of the rounded script letters can be derived from an oval; you may find it beneficial to practice making slanted ovals.

The four S's of script (illustration 2.1) are good rules to follow in any script lettering style: slant, stroke, swing, and spacing:

1. Slant: All letters should slant on the same angle.
2. Stroke: The thick strokes should consistently be the same width, and thin strokes also should be consistent.
3. Swing: The letters and words should have a swing to them. One letter should flow into another smoothly.
4. Spacing: Script letters usually look better spaced close together. Spaces between letters should be the same.

You often get good results by going to extremes in comparative sizes of caps and lower case. The capitals may be four or five times as high as lower-case letters. For heavy script, the capitals may be only one-third higher than the lower-case letters.

On inside-window lettering, script will often be shaded. Shading usually looks best to the right of the letter. When this is done, the balance of the lettering should be shaded on the same side. This is easy on the inside of a window as you are working backwards, and right hand shading is the same as left hand shading would be on an outside sign. It is easier and more convenient to shade window signs or truck lettering to the left for the same reason. (This will be covered later; see illustration 2.12.)

Also try working backwards on the inside of glass. That is, make the last letter first. This enables you to get a better swing to the lettering.

Script looks good when the baseline is at a slant, or running *uphill,* where the wording permits.

Study illustrations 2.2 and 2.3. They will tell you more about script lettering than can be put into words. Script practice gets you into the habit of writing signs instead of painting them. Anyone can learn script by studying the subject and practicing freehand.

There are times when script would be out of place (such as on a "danger" sign), and in these cases, use other, more appropriate letter styles. Don't use too much script. It lacks the good, square stability of the plainer styles.

In laying out script signs with charcoal or chalk, try to get that free and easy swing. Avoid cramped and awkward letters.

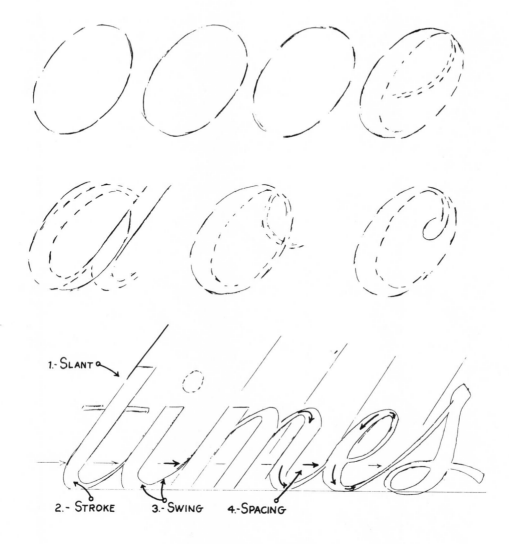

1.- SLANT

2.- STROKE 3.- SWING 4.-SPACING

2.1 The four S's of script lettering.

About the easiest and quickest way to master script is to tack some old newspapers on your board and paint the letters and words freehand, any size, any style, without layout or guidelines. This will help you to get the free and easy swing which is such an important part of good lettering. Repeat the same word many times, trying to improve it as you go along.

Select scripts that suit your style best. Script styles can be mixed to some extent. Simply maintain the size, weight, and proper slant throughout the line and adapt the letter you like.

In illustration 2.4, the first example of the word *Home* has been purposely lettered in a careless fashion to illustrate the importance of consistency of slant. In the second example, notice the smooth manner in which one letter seems to flow into the next and the consistent slant. If the letters are joined at a point too high or too low, the result will be visually unbalanced.

As you become experienced, the spacing can usually be done free-hand, without measurements. Practice that method from the first on show cards.

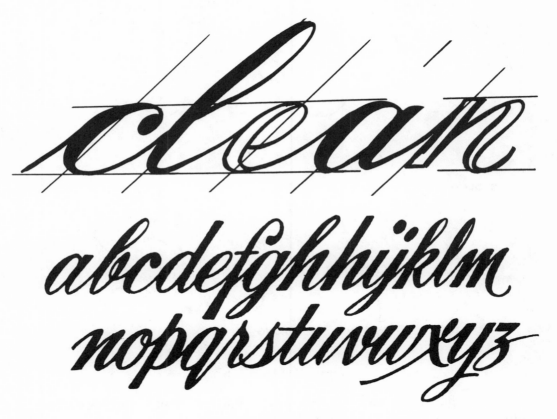

2.2 A script alphabet.

When lettering a script alphabet, you will find that you naturally apply more pressure on the down stroke, less on the up stroke. Thus, you almost automatically begin to develop your ability to letter in thick-and-thin style (illustration 2.5). Thick-and-thin lettering will be discussed more fully later in this chapter.

2.3 Some examples of script.

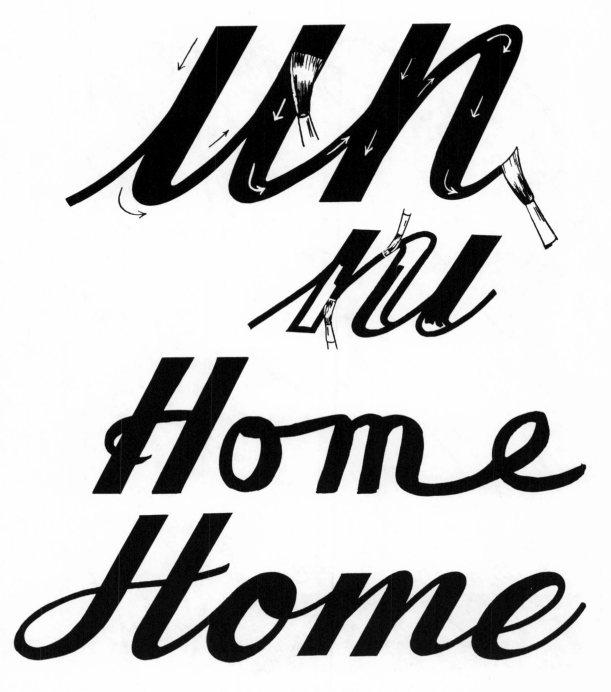

2.4 Notice how the smooth strokes and consistent slant of the letters in the second "Home" make that word more appealing.

ABCDEFGHIJKL
MNOPQRSTUV
WXYZ *Heavy Script* vwxyz
abcdefghijklmnopqrstu

ABCDEFGHIJKLM
PQRSTUVWXYZ&
NO abcdefghijklmnopqrstuvwxyz

ABCDEFGHIJKLM
NOPQRSTUVWXYZ
abcdefghijklmnopqrstuvwryz

1234567890

2.5 The natural tendency to press harder on the down stroke results in thick-and-thin letters.

The modern Spencerian script is a clean flowing script adapted from the old Spencerian quill pen script. Illustrations 2.6 and 2.7 contain the complete upper and lower case alphabet.

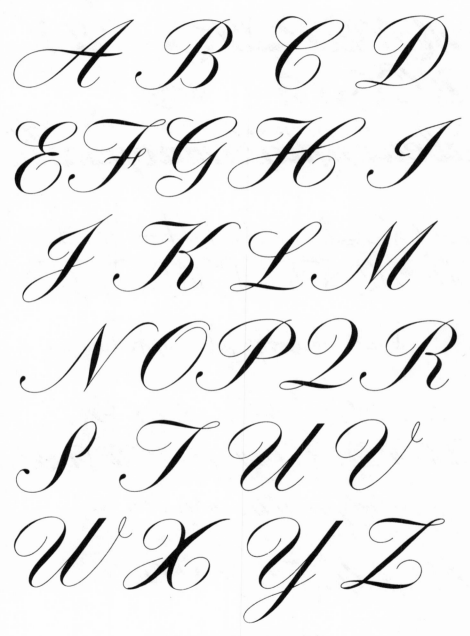

2.6 Spencerian script capitals.

$$a \; b \; c \; d \; e \; f$$

$$g \; h \; i \; j \; k \; l \; m$$

$$n \; o \; p \; q \; r \; s \; t$$

$$u \; v \; w \; x \; y \; z$$

2.7 Spencerian script lower-case letters.

Pencil Line Script

Pencil line script conforms to standard script rules with the exception that all strokes are of the same width, as they would be if they were actually drawn with a pencil.

In lettering a sign using pencil line script, try to attain and then maintain a smooth, flowing sweep to your strokes, as shown in illustration 2.8. This can be achieved most easily through the use of a Speedball pen, a highliner quill, or a sable brush.

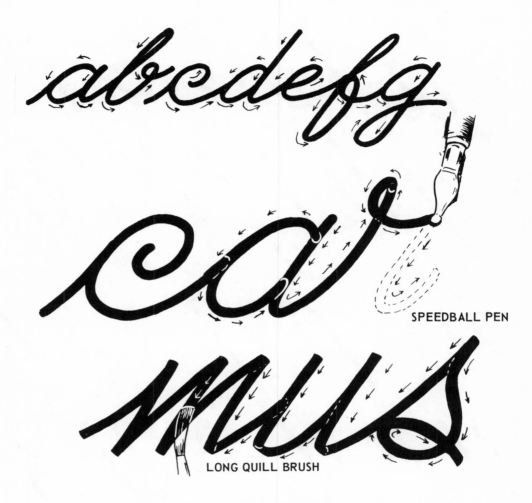

SPEEDBALL PEN

LONG QUILL BRUSH

2.8 Creating a pencil line script.

Thick-and-Thin Lettering

Thick-and-thin is one of the best styles in everyday use. It will prove to be a profitable one in which to become proficient. Using this technique, the letters can be condensed or expanded to fit the available space. Thick-and-thin lettering, when well proportioned, presents an appearance which is pleasing to the eye.

An important detail of thick-and-thin lettering, often overlooked by the beginner, is the *placing* of the thick and the thin strokes. Illustration 2.10 shows examples of both correct and incorrect thick-and-thin lettering.

ABCDEFGHIJKLMN
OPQRSTUVWXYZ&

B C D E F G H
I J K L M N O

quick, brown fox jumps over
the lazy dog abcdefghij
kllmnopqrstuvwxyz

ABCDEFGHIJKL
MNOPQRSTUV
WXYZabcdefghijk

Modern Make Traveling a Picnic

2.9 Variations of pencil line script.

RON

N AH M K

ABCDEFGHI
JKLMNOPQ
RSTUVWXY
Z& 1234567

RON

2.10 Thick-and-thin lettering. The word "RON" at the top and the letters N, A, H, M, and K are incorrectly done.

Romanesque Letters

This alphabet is derived from the Roman, with added heaviness in the thin strokes. The tips are flat, and the spurs, or serifs, are heavier. Romanesque style alphabets and numerals occupy an important place in contemporary lettering (see illustration 2.11).

ABC
DEF
GHIJ
KLM
NPQ

2.11 Romanesque lettering.

48

R S T
U V W
X Y Z
abcdef
ghijkl

2.11 Romanesque lettering(*cont.*).

mnopq

rstuv

wxyz

0123456789

2.11 Romanesque lettering (*cont.*).

Three-Dimensional Effects

When properly used, shading gives letters an appearance of depth and substance. This three-dimensional effect can result in letters which are extremely eye appealing. Illustrations 2.12, 2.13, and 2.14 are examples of both printed and script letters that show the basic shading method. Practice diligently, and you will achieve effective shading.

2.12　Examples of different types of shading.

ABCDE
FGHIJK
LMNOP
QRSTU
VWXYZ

2.13 A printed alphabet with the areas of shading indicated.

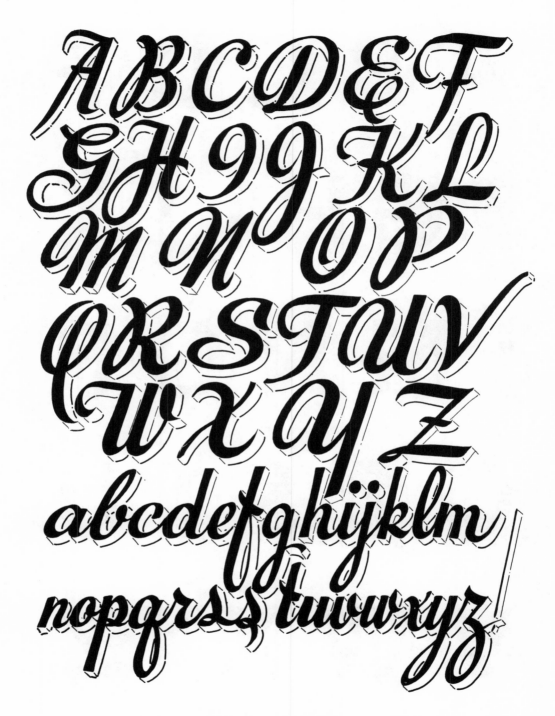

2.14 A script alphabet with shaded areas outlined.

Section 3

Layouts
Thumbnail Sketches
Sign Shapes
The Color Wheel
Use of Color

Layouts

THE layout, or arrangement, of your lettering is even more important than the style of lettering you use. Any lettering can be arranged so that it attracts attention and looks interesting enough to read. But if your layout is too reckless, crowded, or mechanical, it will kill the effect of your best lettering.

There are three necessary elements of a good sign: good layout, good color combination, and good lettering. A crowded, scattered, or confused arrangement of lettering, or a poor color combination, will weaken a sign even more than imperfect lettering.

Observe these four simple rules, and your layouts will appear professional:

1. Leave enough margin so the sign doesn't look crowded.
2. Give the important word or words impact. Use larger or heavier lettering, or use a lettering style which contrasts with the rest of the sign.
3. Keep your design well balanced. It may be helpful to draw a vertical and a horizontal line through the center of your space to make it easier to balance your copy.
4. Try to keep the design appropriate and in harmony with the article or service your sign is advertising.

Illustrations 3.1 and 3.2 show some ineffective and effective layouts.

3.1 Ineffective layouts.

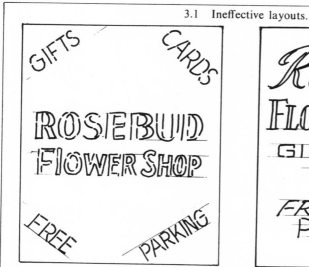

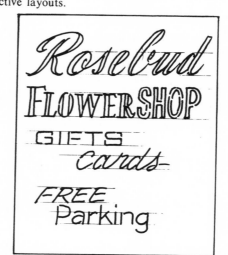

a. When copy is scattered from corner to corner, it is hard to read.

b. When each word is in a different lettering style, the continuity of the layout is broken.

3.1 Ineffective layouts (*cont.*).

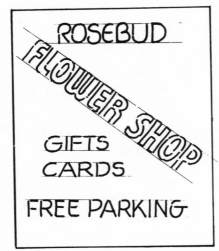

c. When copy runs downhill or at an angle, the letters are hard to read.

d. Arching script distorts the letters; the tops of the letters are too open and the bottoms are too closed.

Illustration 3.3 shows some blank layout ideas which will fit many different workings. They are especially good for truck door layouts or small board signs. You can change the shapes, proportions, or number of lines to suit your wording. These layouts are more attractive than just straight lines of same-size and same-style lettering.

3.2 Effective layouts.

a. The name of a business works well in script. Ovals and other shapes may help a layout.

b. Script slanting uphill and a stripe or ribbon across the lower part of the sign make an attractive layout.

3.2 Effective layouts (*cont.*).

c. Running lines of copy and stripes uphill at a moderate angle give a sign a modern look.

d. Old English and modified Old English lettering may be appropriate for some signs.

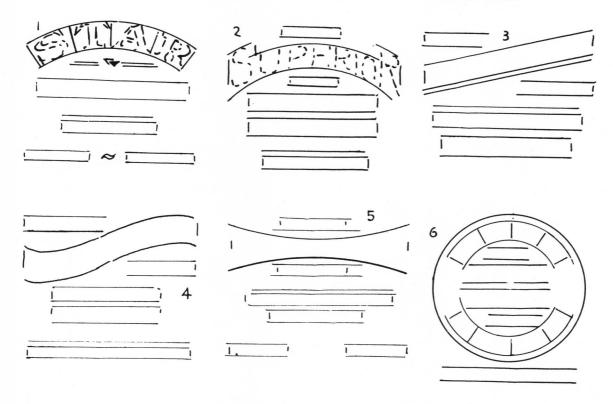

3.3 Blank layouts.

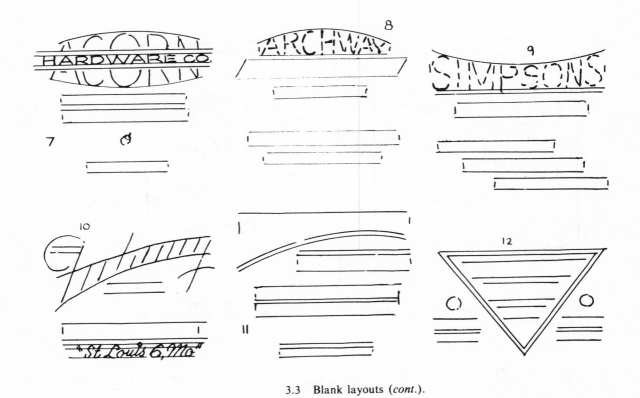

3.3 Blank layouts (*cont.*).

Thumbnail Sketches

When you receive copy for a sign, the best initial approach is to prepare several rough copies (known as *thumbnail sketches*) using differing styles of letters and varying the layout. Select the one which you feel is best, and from this develop a finished sketch which will serve as a layout guide. This process of development will let you visualize exactly how your sign will appear before you touch brush to signboard (illustration 3.4).

The finished sign can't be any better than the creative thoughts behind it. Think! Sketch! Think again! Sketch again! When you are sure that everything is exactly as it should be, then—but only then—begin to paint.

Any sign that carries an illustration of the product in a very simple form will attract more attention than lettering alone. Also, breaking the monotony of all horizontal lines by curving or arching lines of lettering will tend to attract more attention. Consider harmonizing colors or complementary colors that help "catch the eye."

Composition, or layout of lettering along with illustrations, makes more readable signs. It is said, "One picture is worth a thousand words," so think of the effect of "one picture" plus a few informative words. This way, your sign can be made to tell a story visually. Dare to be different. Finished lettering usually is necessary in the display lines to give your work a finished appearance. But some styles of single stroke lettering can be used for most of the body copy. This saves time where there is considerable lettering.

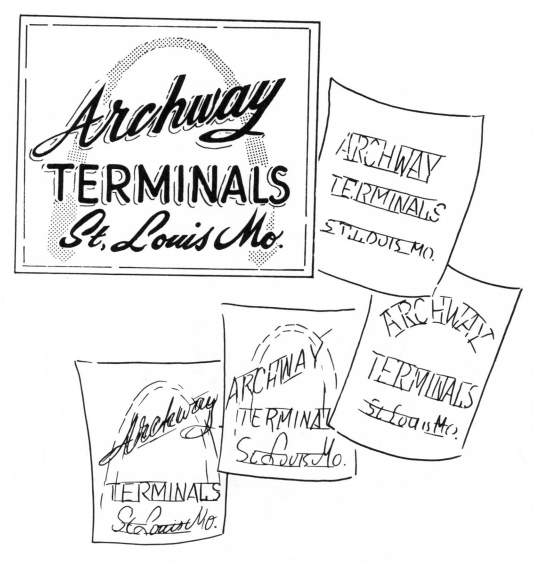

3.4 Thumbnail sketches help you develop the finished sign.

In making a working layout, divide your sketch into four equal parts. Then divide the final sign or the area that you are working into four equal parts. This method will allow you to work in areas no matter how large or small the sign may be. It is important to not have your letters run to the edge of the space. Note how each of the word areas in illustration 3.5 has a space border to give it a unified appearance.

3.5 Divide your layout area into four equal parts.

Sign Shapes

A sign need not be square or oblong. Circles, ovals, triangles, or a silhouette or outline of the object the sign relates to will add to visual appeal. A sign may be designed to fit the building it is mounted on or the product or service it advertises.

3.6 A sign need not be square or oblong.

The Color Wheel*

The color wheel (see inside front cover) shows you how to mix colors in order to obtain new colors and how to obtain beautiful color harmonies. The three *primary colors* are red, yellow, and blue. They form a triangle on the color wheel. These colors constitute a triad color scheme or color harmony.

The three *secondary colors* are orange, green, and violet. They are made by mixing two primary colors. Red and yellow make orange. Red and blue make violet. Yellow and blue make green. The secondary colors also form a triangle on the color wheel and constitute a triad color scheme.

Intermediate colors are red-orange, red-violet, blue-violet, blue-green, yellow-green, and yellow-orange. They are made by mixing a primary color with an adjacent secondary color.

1. A *complementary color harmony* is one that uses two opposite colors on the color wheel. They are yellow and violet, red and green, blue and orange. When two opposite colors are mixed they produce a grayed or neutral hue.

2. A *split complementary color harmony* is one using a color with the two colors adjacent to its opposite, such as yellow, blue-violet, and red-violet.

3. An *analogous color harmony* is one that consists of those colors which lie next to each other (adjacent) on the color wheel. An example would be blue-green, green, and yellow-green. An analogous scheme has one color running through the entire group, as green in the scheme just mentioned.

4. A *monochromatic color harmony* is a one-hue harmony; it uses different values of a single hue. The three values of yellow are monocromatic, as are the three values of yellow-orange, or the three values of red.

Definitions

Hue: the name of the color; for example, red or green.
Value: the lightness or darkness of a color.
Tint: a color lighter than the standard color on the color wheel (white added).

* This material was written by Earl Schmieder, an instructor at The Midwest School of Lettering and Design in St. Louis, Mo.

Shade: a color darker than the standard color on the color wheel (black added).
Intensity: the brightness or dullness of a color.
Neutral: color resulting when opposite colors are mixed; a color without definite identification.

A color may be *warm* or *cool*. In general, colors ranging from yellow-green to red (on the color wheel) are warm. Those ranging from green to red-violet are cool. Cool colors recede; they give the illusion of distance. Warm colors advance; they seem to be nearer to you.

Color and Expression

Color has an impact on our emotions. Warm colors give the feeling of gaiety. Cool colors give the feeling of sadness. More specific examples are:

yellow-green	(warm)	cheerful mood
yellow	(warm)	light, gay mood
orange	(warm)	stimulating, thrilling
red	(warm)	exciting, loud
purple	(cool)	subduing, depressing
blue	(cool)	cold, dignified, quiet, meditative
blue-green	(cool)	passive
green	(cool)	restful, refreshing

Color has extraordinary effects on other elements of design. Size relationships are changed by certain combinations of color. A small, brilliant spot of color such as orange will balance a large area of a neutral color, such as tan. A warm, advancing color such as red dominates an area when used with a cold, receding color such as blue.

Use of Color

A strong contrast is most important when selecting color combinations for sign work. You can get a sample card of colors showing the Outdoor Advertising Association (O.A.A.) standard bulletin colors from any paint store carrying bulletin or lettering colors. Manufacturers provide them without charge. No. 104 bulletin red is one of the most popular colors for sign work. Where the red is to be outlined with black or used as a center for maroon letters, fire red no. 102 is best.

Shade colors may be used for outlines and will give an even stronger contrast. The lettering can be used on backgrounds shown without either shade or outline and still make a good, high-contrast sign. Aluminum and gold may be substituted for white and yellow to make more good color combinations.

Red and black are the best lettering colors on white or other very light backgrounds. Blue, green, and maroon are also used. For lettering on neutral grounds, such as gray, light brown, blue, or green, an outlined letter is best. The letter may be white or another light color outlined with black, red, or another very dark color. Or it may be a dark letter outlined with white or another very light color.

Using an effective color combination with a good, attention-getting layout will spell success.

Section 4

The Pounce Pattern
Truck Lettering
Window Lettering
Transparent Strips
Gold Leaf
Silver Leaf
Surface Gilding—Gold Leaf
Gold Leaf Truck Lettering

The Pounce Pattern

THE pounce pattern system is of great value when a number of duplicate signs must be produced rapidly. The system is similar to the use of patterns and pattern wheels in sewing.

The layout is drawn in finished form on a sheet of heavy paper, the same size as the signs to be produced (illustration 4.1). A pounce wheel, a toothed wheel similar to the type used in sewing to transfer patterns to material, is used to trace the pattern by exerting enough pressure to create cleanly punctured holes in the layout paper. When the complete design has been punctured in the paper, fasten the pattern over the sign area. Now you are ready to apply the pounce powder.

On light-colored work surfaces, the pounce powder usually is a powdered charcoal mixture. Talcum powder usually is used on dark surfaces. Place a quantity of the powder on a small piece of cotton rag, lift the corners, and tie at the top to form a bag. (Filling an old sock with pounce powder works well, too.) Now pat the bag while moving above the surface of the layout paper with the punctured pattern. When the entire surface has been dusted with the pounce powder, lift the paper; the design will have been transferred to the work surface, a tracing created by the powder passing through the punctured holes.

Truck Lettering

Truck lettering is one of the fastest growing branches of commercial sign work. The number of trucks on our streets and highways has been increasing every year, and owners are becoming more conscious of the great advertising value of truck signs. Instead of lettering a truck with plain letters, you have a chance to sell the customer a total design including graphics and logos.

Before lettering a new truck, wash the panels or doors with a cleanser such as Comet or Ajax and rub with a dry rag to remove all wax. Make a pounce pattern of the exact size of the lettering space, using a piece of poster paper or brown wrapping paper. Sketch the layout roughly with chalk or charcoal, and then correct it with a soft lead pencil. Now go over the lines with your pounce wheel to perforate the paper. Do this on a piece of soft wall board, or lay a thin piece of old blanket on your show card table. Place your pounce pattern paper over the soft surface, then trace the pattern. Turn the paper over and rub the back lightly with sandpaper to open the pounce holes.

Fasten the pounce pattern to the proper place on the truck with tape and go over it with a pounce bag. After the surface has been pounded and the paper pattern removed, the truck is ready to letter with aluminum paint, imitation gold, or color to suit. When your colors get lumpy, strain them through a piece of old nylon stocking. Lettering enamel works best on trucks.

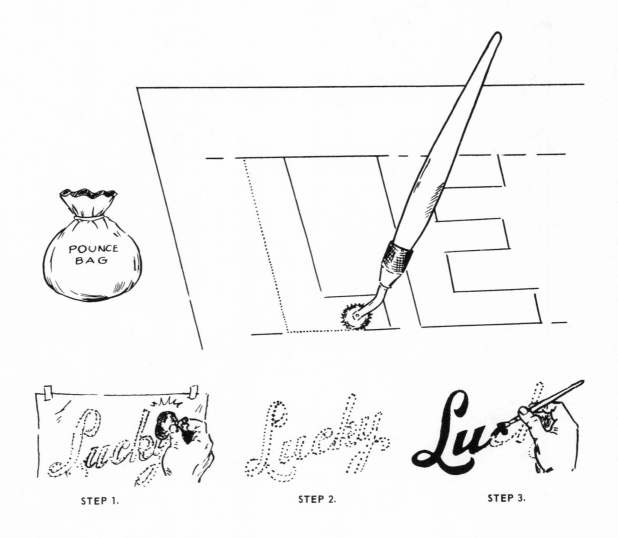

STEP 1. STEP 2. STEP 3.

4.1 The pounce pattern is traced with the pounce wheel. Then the pattern is transferred to the surface to be painted by dabbing the pattern with the pounce bag. The pattern is removed, and the outlined design is painted.

When no special design is used, you can make a layout directly on the side of the truck. Use a yardstick to lay out lines of chalk so they will be even and straight. Rub some chalk on your chalk line and snap all top and bottom lines of lettering. If you are going to shade any of the lettering, snap another line for the bottom line of the shade. Some painters lay out truck lettering with chalk or a stabillo no. 8040. (A stabillo is a soft-lead pencil, somewhat like a grease pencil, that comes in all colors.) The lines of a stabillo can be easily wiped off the surface with a damp cloth. A regular lead pencil will scratch the truck's paint.

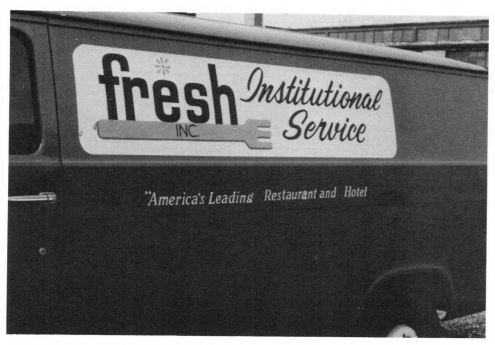

4.2 The lettering on this truck was designed by the author. Fresh Inc. is a wholesale food distributor. The customer had several trucks, so a sketch and pounce pattern were made.

You can use one-half inch transparent tape along top and bottom of small lines to square up ends of lettering easily. Just pull your letter stroke right over the tape, and after lettering is done, pull off the tape to square up the letters. This is a good technique sometimes, but don't depend on it too much because it makes your work look too stiff. This is not recommended for a freshly painted truck or a surface with soft paint, either, as the tape will pull off the background color.

4.3 This truck had a standard lettering job. The customer had only one truck, so no pattern was made.

Window Lettering

Most inside window signs, except those done with gold or silver leaf, are painted with aluminum, gold bronze, or as a transparency. If you are lettering on the inside of the glass and not using a pounce pattern, make a chalk layout on the outside of the glass. Rub vinegar on the outside of the window so your chalk layout and guidelines will mark easily. Keep the chalk sharp in order to sketch an accurate layout.

Pigments such as aluminum and gold bronze come in powdered form. You must use super-fine lining bronze dust. A dust that is not finely ground will not mix well or cover when used with a brush. Fibroseal, liquiseal, or a good grade of clear varnish is used as a binder.

It is important to mix your bronze in the following order, to prevent lumpy paint:

1. Place the dust in a clean container.
2. Add a few drops of binder. Mix well. Add a few more drops of binder, and mix it into a paste.

3. After the paste is mixed well, add more binder and thin with a small amount of turpentine until the paint flows from the brush smoothly without dragging.

Aluminum dust is handled the same way. After the letters are completely dry, you can shadow and paint the back of the letters with Japan black, jet black, or gold leaf backup black. If black lettering color is used, it will have to be double-coated to make it opaque.

All windows lettered on the inside must be varnished with "W and W" window spar or a good grade of clear varnish to prevent rubbing off.

Here is an aluminum formula that produces signs almost equal to silver leaf when used on the inside of glass. Use Dick Blick or Super Fine Aluminum Dust or Superfine Silverplus paste. Place a small lump in a clean can, and mix it with lacquer thinner to form a heavy paste. Then add a little clear brushing lacquer for binder. Do your lettering with this, adding a few drops of thinner and clear lacquer as you go along to keep the paint working smoothly. Use a clean gray camel or squirrel hair quill and wash it in lacquer thinner before and after use.

Transparent Strips

A transparent strip across the top of a window is called a ribbon. The letters are painted on the inside first, usually with opaque black. Arrange the ribbon for balance. For instance, if the letters are 6 inches high, you will drop down 3 inches from the top of the window and snap chalk lines on the outside of the window, top and bottom, for the 6-inch letters. Then drop down another 3 inches and snap double lines about one-half inch apart. The one-half inch lines form a "clean-up" line to divide the ribbon from the rest of the window.

After the lettering is completely dry, add linseed oil to the lettering or bulletin color you are going to use for the background. This will slow the drying time to complete the stippling procedure. Fill in the 12-inch space above the clean-up line with paint.

Make a stippler by wrapping a piece of cheesecloth around a wad of cotton. A clean, lint-free, white, cotton rag can also be used by wadding it up, keeping a smooth side (free from creases) for stippling. Stipple by tapping the stippler over the painted surface. Stippling takes out brush marks and gives the window a transparent, sprayed look. This procedure can be reversed by painting an outline around the

letters, leaving them open, and then painting the ribbon around the letters. Opaque and stipple the open letters. See the "Cocktail Lounge" and "Maxwell Photographs" examples in illustration 4.4.

Gold Leaf

Gilding is considered the highest branch of sign art. The gold leaf used comes in books of twenty-five leaves, 3⅜ inches square, put up between sheets of tissue paper. The cardboard box containing twenty books is known as a pack. The best "XX" of deep gold grade is about 23 karat. Pale and lemon gold range from 14 to 18 karat. They are lighter in color but equally good for inside lettering on glass. Only the 23 karat gold should be used for trucks, board signs, and other outdoor surface gilding, as the lighter gold may tarnish when exposed to the elements.

Besides your regular sign lettering materials, these are the special materials needed for gilding on glass:

Two books "XX" glass gold (enough to start)

One clean grease-free pint can and cooker

1½-inch or 2-inch size brush (a short-bristled brush made of soft hair, sable, or camel hair for applying gelatin water size)

Camel hair gilding tip

Chamois skin

Blank gelatin capsules, absorbent cotton, single-edge razor blades, and white chalk

Gold leaf is very delicate and cannot be handled with the fingers. Handle the books carefully, and do not allow them to come in contact with anything wet or oily.

Handle the gilder's tip and size brush with care, and keep them away from paints. Most sign painters use an alcohol heater for boiling water. You can also cook it on a stove.

First draw your design or layout carefully on the outside of the window with white chalk or a red wax crayon. For small or complicated designs you can draw the design on a piece of paper and make a pounce pattern of it. Cut little triangles in the top corner of the pattern for key marks. The key marks allow the pattern to be lined up with the layout on the outside of the glass when it is pounced on back of the gold. Pounce this on the outside of the window before you lay gold leaf on the inside. (See illustration 4.5a.)

4.4 Some examples of lettering on store windows.

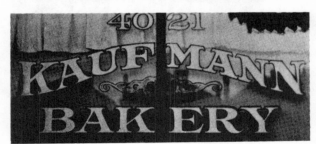

4.4 Some examples of lettering on store windows (*cont.*).

Wash the inside of the window with water or kitchen cleanser. Use alcohol first if the glass seems greasy. Then polish it carefully with a clean lint-free cloth or tissue, and flow clear water over the entire space with your brush. This will carry off all dust specks. Be careful not to touch the glass with your fingers while you are working. Let the glass air dry.

Put a small amount of water in your size can and place it on a Sterno cooker, or whatever you use to heat water. Put in about two or three empty no. 0 size gelatin capsules, and allow them to boil and dissolve. (Blank capsules may be obtained from most drugstores.) Add enough water to make one pint, and allow it to boil for five minutes. Strain this through clean, white, cotton cloth, and the water size is ready to use. If the sign is small, size the entire design using your water size brush (illustration 4.5b). If your layout is large, work on part of it at a time. The area you are working on must be kept wet with gold size at all times so gold will stick. If you are right handed, begin at your upper left-hand corner.

Work near the sign area. Lay your book of gold on a piece of stiff cardboard 3½ inches square. Hold these in your left hand. It is difficult to lay whole leaves of gold, although an experienced person can do it. Fold the tissue paper back halfway, and cut the gold leaf with the nail of your little finger along the fold of the paper. This is done with the right hand, which also carries the gilding tip. Be careful your hands do not touch the leaf.

Now rub the gilding tip across the hair on your head or a woolen coat sleeve, and pick up the gold with it (illustration 4.5c). By laying the tip on top of the leaf, static electricity will pick up the gold leaf. Carry the tip to the window, and as soon as it is near the size, the gold leaf will jump to the window. Don't allow the gilding tip to touch the water. Don't try to carry the leaves too far. Hold your left hand with the book of gold fairly near to the window (illustration 4.5d).

Leaf the window solid where the design is to be. Keep the window wet ahead of your work, but don't allow water size to flow over the gold which has just been laid, or it'll wash off. Allow the leaves to lap over each other about a quarter of an inch. Don't be stingy with your leaf; allow a small margin of gold around the space where the design is to be.

After the gold has dried, which may take only a few minutes or considerably longer, and the glass is cold, it is ready to burnish. Take a

4.5 Applying gold leaf.

a. (View: Front of glass) Pounce pattern on the outside of the glass. Also pounce key marks.

b. (View: Back of glass) Flood the area with water size.

4.5 Applying gold leaf (*cont.*).

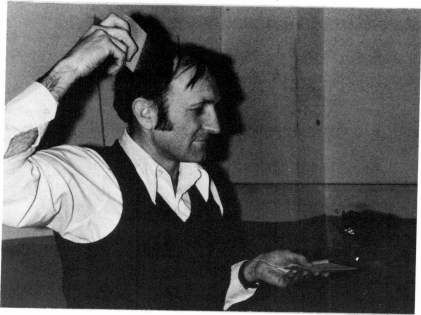

c. (View: back of glass) Static electricity is created by stroking the guilder's tip across your hair. A gold leaf is lifted from the book with this static.

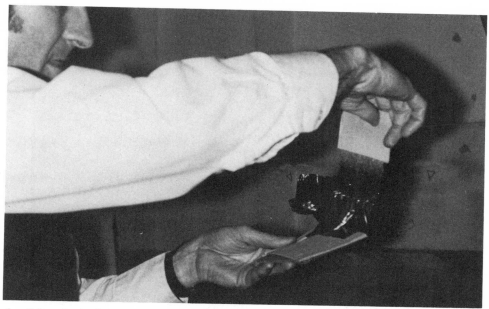

d. (View: back of glass) Hold the gold-leaf book near the glass so you won't have far to carry the leaf. If the leaf folds or wrinkles in the book, shake it or blow it lightly to straighten it.

4.5 Applying gold leaf (*cont.*).

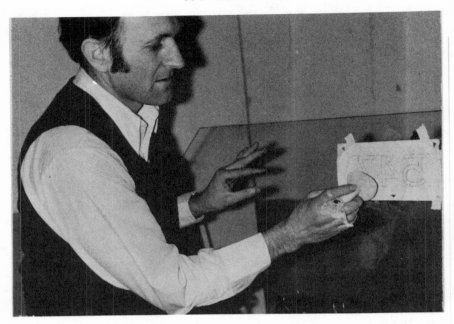

e. (View: back of glass) After the gold is dry, line up the key marks and pounce the pattern on the gold.

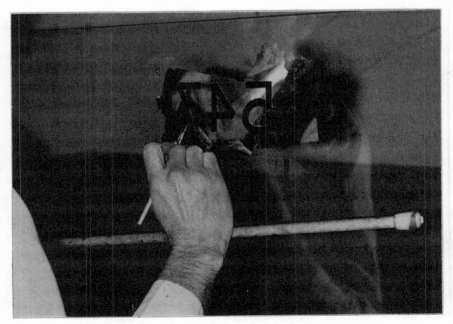

f. (View: back of glass) Paint the figures on the gold.

4.5 Applying gold leaf (*cont.*).

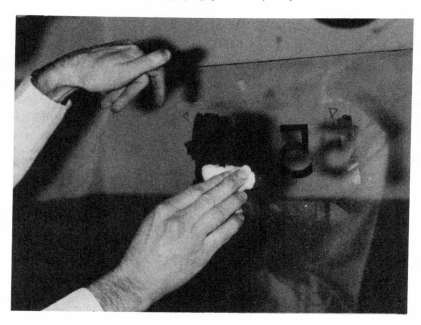

g. (View: back of glass) Gently wipe the excess gold away from the figures with a damp cotton wad.

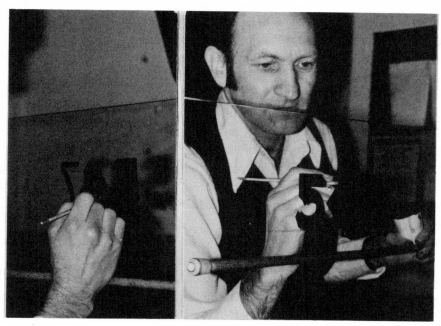

h. (View: back and front of glass) Figures are shadowed, usually with jet black.

soft piece of absorbent cotton and brush off the loose gold, then burnish by rubbing the gold briskly—but very lightly—with a wad of clean cotton. A portable hand-held hairdryer may be used to dry the gold.

After the gold is burnished you will see a few holes and imperfections in the gild, so give the whole design another coat of water size with your size brush. Do it quickly, and don't brush over the gold a second time while flowing this coat on, or it will take off the leaf. Now apply very small pieces of gold to the holes, or *holidays,* and allow the gold to dry again. After everything is dry, dilute your size with an equal amount of water. Bring it to a boil, and go over the sign again with your size brush and the hot size, or with clean hot water. This is called "washing." It gives the gold a mirror finish.

When the gold is dry, take a pin or needle and scratch very fine lines to mark the top and bottom of the lettering. Now paint the backs of the letters with jet black or Japan lamp black thinned with clear Fibroseal, Japan gold size, or quick-rubbing varnish. Use a small camel's hair quill, and thin the color a little with turpentine as necessary. There are several prepared backup colors: you can use clear lacquer and Japan color, home-mixed shellac, or paste aluminum mixed with lacquer, as described under "Window Signs." Jet black is used most often. It is made especially for backing up gold leaf.

After the backup color is dry, trim the ragged ends to line with a new single-edge razor blade. Then take a piece of absorbent cotton, dampen it in a pan of water, and go over a letter or two, following with a dry wad of cotton to wipe off surplus gold. Use straight strokes beside the straight letters, and rub with rotary motion in the round letters to avoid breaking the backup color.

Next, with a damp chamois, rub off small particles and clouds of gold that still adhere to the window. A small mirror reflected on the back of the letters will help you to see the small particles of gold without going outside the window. A portable electric hairdryer is very handy for drying gold leaf in cold weather and helps to speed up the work.

Next, shade or outline the letters with Ivory Drop Black or other Japan color. This may be trimmed with a razor blade, or cut off square using the scotch tape method discussed in "Truck Lettering." When dry, the entire sign should be varnished with Valspar or other good window spar. Allow the varnish to extend about ⅛ inch beyond the paint, all around.

To make straight gold leaf stripes on glass, snap chalk lines for the width of the stripe on the outside of the glass. Lay leaf on the inside, going liberally beyond the edges of stripe with your gold. When this is patched and burnished, lay a yardstick along the stripe. Use a sharpened, soft, wood wedge, dampen it in your mouth, and pull it along the edge of the stripe with considerable pressure. This will take off a clean, straight stripe of gold the width of the wedge. Back up the remaining center stripe of gold with clear lacquer, Fibroseal, or quick rubbing varnish, and when this is dry, clean off the surplus gold.

If you have considerable striping to do, buy ribbon gold, wider than the stripe is to be. Size the window, unroll 1½ or 2 feet, and hold it up to the sized glass. It will jump to the glass. Now you can tear off the tissue, and unroll another length. Very little, if any, patching is required.

You can make perfect gold leaf circles on glass by fitting a wooden wedge in place of the pencil in your compass. Put a number of pieces of scotch tape crisscrossed over each other on the glass for resting the center leg of the compass, or tape a little block of Masonite to the window for centering. Backup can be handled the same way as you did for the straight stripe.

Silver Leaf

For silver color, Palladium is the best and easiest to handle, and it works just like gold leaf. Silver leaf may be used, but the water size should contain about twice as much gelatin. Use a badger or ox hair tip instead of camel's hair. The tip may be moistened with size to enable you to pick up the silver better.

To make a two-tone job with one gild, the lettering is marked on *outside* of the glass with a red grease crayon. Clean the glass on the inside of the window. Rub water with a small amount of cleanser all over the space to be gilded. This leaves a slight film on the surface so that you can paint a center in the letters with clear Japan gold size or dead center varnish and the brush strokes will show plainly. When this is dry, rub off the surrounding whiting, apply water size, and gild with XX gold. Back up and finish the same as a one-color gold job. Such jobs may be outlined with Prussian blue because it is easy to see the width of the outline with this transparent color. You can make it black afterwards by rubbing over the back of the still tacky blue with a powder puff coated with powdered graphite.

If varnish crawls (beads up or spreads apart) on the back-up color, rub over it with a damp rag and whiting. Clean it off with damp chamois.

Surface Gilding—Gold Leaf

The sign letterer is sometimes called upon to gild lettering that has been carved in stone, such as names on buildings, corner stones, tombstones, and so on.

The proper method is to give the carved letters a coat of shellac, being careful that there are no "holidays" or skipped places in this prime coat. Brown shellac can usually be seen better than white shellac for this purpose, but either one can be used. This shellac coat dries almost instantly and prepares the surface so the next coat will not soak in. It is almost impossible to do a good job of gilding on stone without it.

Wood cut-out letters are often surface gilded. Give the letters an even coat of gold size, brushing the size out well to avoid getting the color too thick in spots. Avoid holidays, as the smallest bare spot will leave a bad blemish in your gild. When the size dries so that you can rub your finger across it without picking up any paint, it is ready for the leaf. The size should "whistle," or give a little squeaking sound when your finger is pulled across it. Otherwise, it is too dry.

Imitation gold lettering enamel is a good quick size for surface gold. It dries to gild in about an hour, depending on the atmospheric conditions and how much imitation gold you have used. Hastings Synthetic Gold Size dries to a "whistle" in about two hours, depending on the weather and amount of yellow used. Clear Fibroseal can be used in cold weather, but it dries too quickly in the summer.

Gold Leaf Truck Lettering

Wash the panels to be lettered with naphtha or gas to remove all wax or grease. Then polish them with a dry cloth, and rub over the surface with a bag of talcum to make sure there are no sticky spots. If the talcum sticks to any spot, rewash that area. Do not transfer the pounce pattern until the panels are clean.

Snap a level line at the same place on each side of the truck to keep your pounce pattern in the same position on both sides. Fasten the pattern to the truck with tape and transfer as discussed in the sections on the pounce pattern and truck lettering. For a gold size, mix Skoler

Imitation Gold—a light-yellow paint—with Hastings Quick Gold Size. A little turpentine may be added to make your color work smoothly. In cold weather, add a little clear Fibroseal. Mix well and strain through a piece of nylon stocking to remove all lumps.

Letter the bottom lines first, if you can work that way. By working upward, the bottom lines will dry for gilding first and your surplus gold will not fall on the freshly sized letters. The size should be almost dry before you lay the leaf. Have just enough "tack" so that the paint will "whistle" when you rub your finger across it, but no paint will stick to your finger. White paint should be used in the size for aluminum leaf, and it needs a strong "tack" when the leaf is laid.

If you are working inside, out of the wind, it is best to gild with loose XX gold direct from the book, as you get a better burnish than with patent gold. If you have to gild out of doors, use patent gold, which is XX gold lightly fastened to tissue sheets. In either case, rub the gold on the size through tissue paper and burnish the letters by rubbing briskly with a wad of absorbent cotton. If the gold won't stand a good burnish, the size is too wet, and the job will not last.

In an emergency, you can lay loose gold leaf out of doors in the wind by using a piece of waxed paper a little larger than the leaves of gold. Lay the waxed paper over the sheet of gold, and rub it down. The gold will stick to the paper so that you can carry it to the lettering. The size will pull the gold off the waxed paper. Use the same piece of waxed paper repeatedly.

After the sign is gilded and burnished, outline the letters with black, bulletin red, dark blue, or chrome green, depending on the color of the background. Use 1¼ inch camel hair quills, nos. 1, 2, and 3, to apply the outline. Mix the color with varnish and turpentine, then strain it. Fibroseal may be used in place of varnish for quick drying.

Section 5

Show Cards and Banners
Show Card Layouts
Show Card Alphabets
Silk Screen Printing

Show Cards and Banners

SHOW cards are temporary signs done on poster board and are sometimes called card signs. Temporary paper signs are called banners. Show cards and banners usually are made with show card colors. These come in glass jars, are inexpensive, and may be thinned with water as necessary.

Round, red sable show card brushes are proper tools to use with show card or poster colors when using watercolor. A set of three brushes, sizes 4, 8, and 12, is adequate to begin with (illustration 5.1).

Buy the best grade of brushes, and always wash them out carefully in cold water after use. Keep them standing hair end up in a glass or vase when not in use. Treat them well, and they will last for years. In fact, a good red sable may even improve with age.

Show card brushes are usually held between thumb and first finger down on the metal ferrule. The handle should point up, almost at a right angle to the surface you are working on (illustration 5.2). Hold the brush lightly, just firm enough that you can rotate it easily between thumb and finger as you go around the curves on letters.

After dipping your brush in color (black is good for practice), work it out flat on a piece of glass, card, or paper to give it a chisel shape before you try to do the lettering.

If you are a beginner, it is a good idea to tack an old newspaper to your show card table and practice the letters and basic letter strokes over and over, without guide lines, to gain confidence in your brush work. In making the thick-and-thin alphabet, the brush is not rotated between thumb and index finger, but is held in one position and used edgewise for the thin strokes.

Small lettering may be done with a Speedball pen and black waterproof drawing ink. The style B pen has a round point and comes in various sizes. Use it in a regular pen holder. It isn't necessary to square up the ends of the letter strokes (illustration 5.3).

The Style C Speedball is used for Old English and other styles of text lettering. Hold the pen just as you would a regular writing pen.

Card writing and sign painting are two different trades. Only about one person in ten seems to master them both. Many sign letterers make cards, but they usually look like signs. Most small shops have to do both kinds of work. In card writing, letters are adapted to the show card brush so that the work is faster and less mechanical than sign lettering.

5.2 The correct angle for brush lettering.

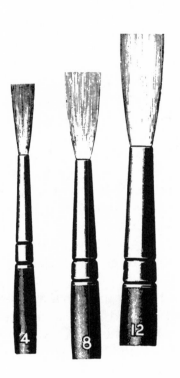

5.1 Red-sable show card brushes.

5.3 Lettering pens come in a variety of points and sizes.

Show Card Layouts

Most show cards are made in standard sizes to cut in even numbers from the regular 28 inch by 44 inch board. This will make four 14 inch by 22 inch, two 22 inch by 28 inch, eight 11 inch by 14 inch, or sixteen 7 inch by 11 inch cards. Anything smaller is usually classed as a "price ticket."

On dark cardboard, use white chalk for the layout. When the lettering is dry, remove the chalk lines with a soft piece of chamois

skin. In any case you should get into the habit of making your layout very light, so that it will erase easily. Dark cards can be waterproofed with spray fixative.

Almost any mistake on a paper or card sign can be corrected easily. On paper signs, use a razor blade to cut out the mistake. Paste a slightly larger piece of the same paper or card over the hole on the back of the sign and reletter.

On white cards, scrape the mistake off carefully with a single-edge razor blade and letter again. If necessary, you can touch up with white show card color. On dark cards, you can usually wash off the letter that is wrong. Do it quickly, but carefully, with a damp wad of cotton or a clean damp cloth. If necessary, paint on a panel and glue it over the mistake.

The following pages illustrate a modern show card style which I call "headline half-script." It is intended for banners and not for long text matter. This brush style is a cross between script and Gothic. It should be done freely with a minimum amount of layout. It can be Gothic such as illustration 5.4, or an upright script, as shown in illustrations 5.5 and 5.6.

The script style shown should not be used on cards with long copy. Rather, it is for headings and occasional use. The cards in illustration 5.5 show the limits to which you can go in use of this lettering. It needs some Gothic or other plain style mixed in, like the word "watches" in the upper right corner or "Duval Jewelry Co." in the other sign, to stabilize the design.

This has been called a "Florida style," although it is just as popular in New York and many other places. Once you have mastered it, you can make many other graceful modifications to suit your individual swing and taste.

To add contrast, color spots can be painted first in a contrasting color, and then prices can be lettered over the color spot. The skillet sale sign (illustration 5.4) is an example of this.

The easy formation of this script tends to make it flow from the brush into words. The letters should usually be "close packed" for best appearance, and no shades or outlines are required. The lettering doesn't have to follow the guidelines exactly either. If some letters are a little above or below, the effect is still pleasing.

The "sale" sign in the lower right corner shows letters done rapidly, as you might do them on a "knock out" show card, without any

5.4 Gothic brush lettering.

5.5 Upright script brush lettering.

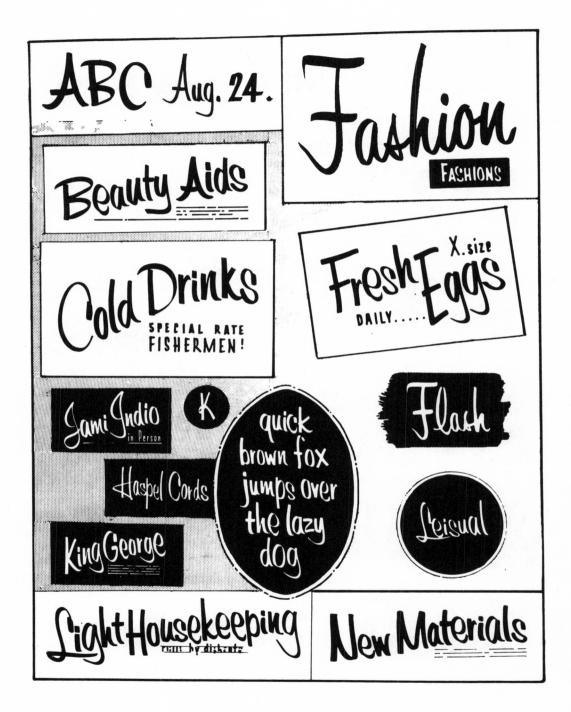

5.6 Upright script brush lettering.

touching up. This casual lettering can be made rapidly after a little practice, and it is easy to read in addition to having that graceful swing which attracts attention.

If you can master this style, your cards will look like show cards instead of signs. Study the style closely, and render the words freely. Small lettering can be done with a Speedball.

Leave plenty of margin. If you have long copy, group it tastefully, without filling the entire card. Make the important words big and the balance of the copy small.

Show Card Alphabets

The casual lettering as used on the show cards illustrated is of the very latest style and is much used in display advertising. In these alphabets, we pay more attention to easy and graceful swing than we do to the rules of Roman lettering in the placing of thick-and-thin strokes.

The brush is pulled in a different manner from the older types of show card alphabets. This is especially true in the round letters and figures such as the G, S, and 3. Those strokes are clearly shown in the alphabets in illustration 5.8. The letter G requires at least one less stroke than earlier styles, because the first stroke is pulled around to form not only the back of the letter but also the front. This continuous stroke adds grace and swing to the letter, but "pushing" the stroke uphill takes a deft touch and practice. You must have a good red-sable brush that chisels well, and the color must be thin enough to work smoothly in order to do this stroke.

The letter S and the figure 3 are each formed with two brush strokes, instead of at least three strokes used for most other styles of show card lettering. The first two alphabet plates illustrate the number of strokes required for each letter.

Pages 94-101 illustrate various show card alphabets and their applications.

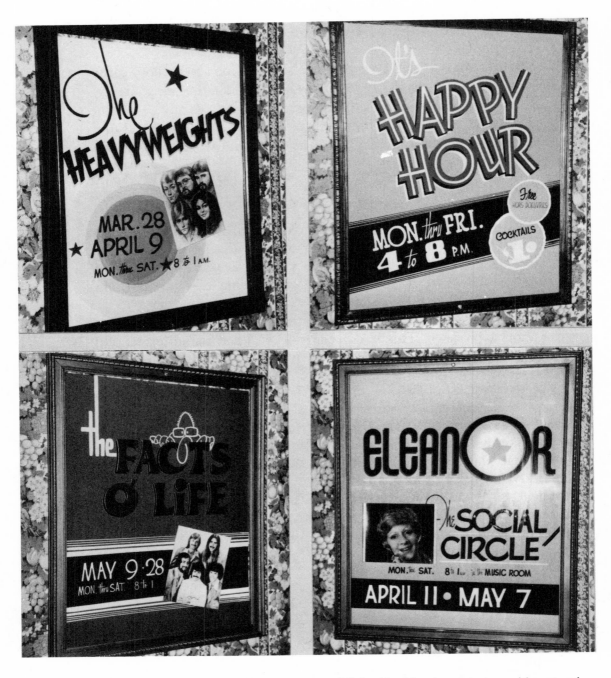

5.7 These show cards by Max McCluskey of Columbia, Mo., demonstrate good layout and design as well as flair.

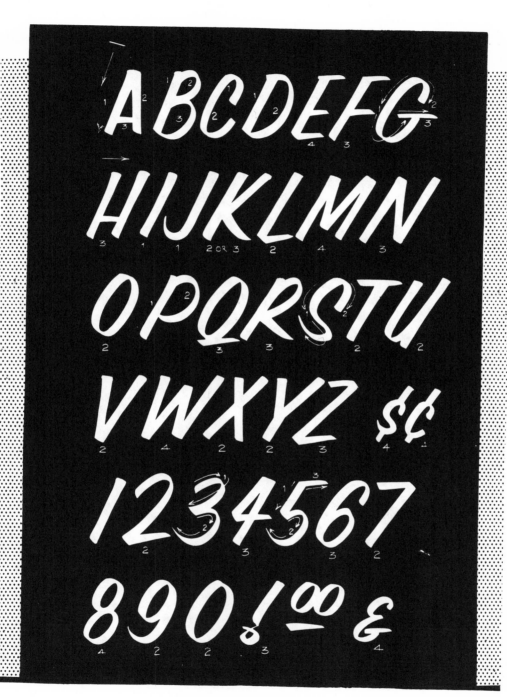

5.8 Show card alphabets.

abcdefghij

klmnopqrs

tuvwxyz

agkssty

Federal quick

strong haven

5.8 Show card alphabets (*cont.*).

ABCDEFGH
IJKLMNOP
QRSTUVW
XYZ 12345^{00}
67890 ?!&$¢
MENU PRAY

5.8 Show card alphabets (*cont.*).

abcdefghijklm
nopqrstuvwxyz
staggered first
jewelry chenille
open closed at
rapid labored by

5.8 Show card alphabets (*cont.*).

ABCDEFG
HIJKLM
NOPQRST
UVWXYZ
abcdefg
hijklmnopq
rstuvwxyz

5.8 Show card alphabets (*cont.*).

ABCDEF
GHIJKL
MNOPQR
STUVWXYZ

ABCDEFG
HIJKLMN
OPQRSTU
VWXYZ

12345
6789

abcdefghi
jklmnopq
rstuvwxyz

ABCDEFGHIJ
KLMNOPQRS
TUVWXYZ!

5.8 Show card alphabets (*cont.*).

ABCDEFGHIJKL
MNOPQRSTUVW
XYYZ & 1234567

ABCDEFGH
IJKLMNO
PQRSTUVW
XYZ23457

ABCDEFGHIJKLMNOPQRST
UVWXYZ& 1234567890

ABCDEFGHIJKLMNOPQR
STUVWXYZ& 123456789

5.8 Show card alphabets (*cont.*).

Silk Screen Printing

The silk screen method of printing is a good way to handle signs in quantity. When you have ten or more identical signs with a lot of copy, it is to your advantage to use silk screen. This can be a simple hand operation or a highly sophisticated, automated one. You have probably never realized the vast amount of material that is silk screened. All types of signs from real estate boards to plastic signs are silk screen printed, as well as many fabrics. T-shirts are a popular screened item. Drinking glasses, toys, and beer cans are screened. Vinyl and lacquer decals are silk screened, as well as anything else that is printed and won't fit into a press. A company that specializes in silk screen printing has automatic presses and dryers to speed up their production.

Illustration 5.9 shows how T-shirts are printed, step by step. Materials required are:

Textile ink
Thinner
Gelatin film
Squeegee
Silk screen

An accurate layout of the copy should be made. A lacquer film, called Nu-film, is taped over the top of the layout, dull side of the film up. Nu-film is amber in color and comes in rolls. The top, or front, is dull and amber. The back, or bottom, is shiny and frosty white in color. The film is translucent, and the layout can be seen through it. The shiny side of the film is the backing.

An Exacto knife is used to cut the letters out of the film. Use very little pressure on the knife when cutting the film as you do not want to cut through the backing. After the letters are cut, they should be peeled off the dull surface of the film.

Making a Silk Screen Frame

Usually silk screen frames are made from 2 inch by 2 inch wooden lengths cut to the desired size, with the corners mitered. The ends are nailed together. See illustration 5.10.

A one-eighth inch groove about one-half inch deep is cut in one side of the wood lengths. The silk is cut 2 to 4 inches larger than the frame size. Four pieces of one-eighth inch cotton rope are cut to lengths equal to the total frame circumference. Lay the frame down flat with

5.9 Silk screen printing on fabric.

a. Fabric must be stretched so it is wrinkle-free. A piece of cardboard is slipped inside the fabric to hold it to form and to prevent ink from bleeding on the second layer of fabric.

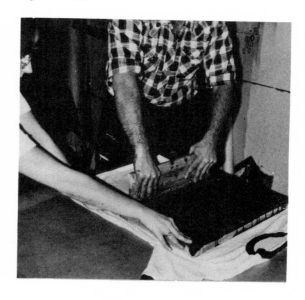

b. Screening ink is poured at one end of the frame, and the squeegee is pulled across the silk screen.

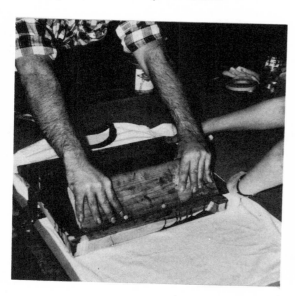

c. The frame is hinged to the table or bench, which allows easy access to the material being screened.

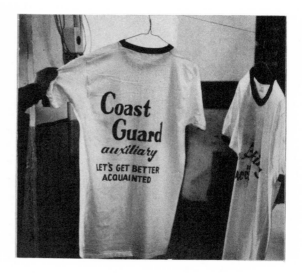

d. When printing on both sides of a T-shirt, you must allow the first side to dry before printing the other side.

5.10 Making a silk screen frame.

a. Lengths of wood, 1½ by 2 inches, or 2 by 2 inches, are cut to size and mitered.

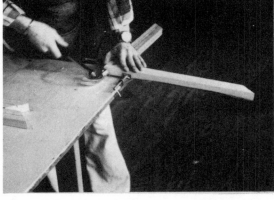

b. The corners of the frame are nailed with finishing nails.

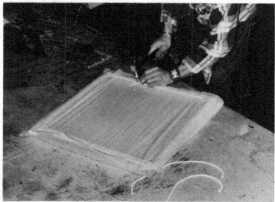

c. Rope is pounded into the groove of the frame to tighten the silk.

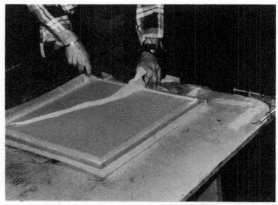

d. Excess silk is trimmed from the frame.

e. The completed frame is ready for use.

f. The frame is placed on top of the film, and the film is adhered to the silk.

the grooved side up. Lay the silk over the frame with the silk overlapping equally on all four sides. Using a hammer, drive the rope into the groove. As the rope is forced into the groove, the silk tightens on the frame. When all the rope is used, the silk should be stretched tight and wrinkle-free.

A tightly stretched screen is essential for a clear print. The silk screen should be made larger than the copy to be used on it. For instance, if you have three lines of copy combined to make up an area 10 inches by 16 inches, you would make the screen 22 inches by 28 inches, inside dimensions.

Squeegees have a hard rubber edge with a wood or aluminum base shaped for the hand hold. They can be obtained in any length. Most suppliers cut squeegees to the size desired. You should use a squeegee 12 inches by 14 inches wide, leaving 1 or 2 inches over the copy area. If the squeegee runs too close to the edge of the frame, it may break or tear the silk away from the frame.

Adhering the Film to the Silk

To adhere the film to the silk, lay the film flat, gelatin side up. Lay the screen on top of the film, back or flat side down. Wet a sponge with adhering liquid or lacquer thinner, then squeeze the excess fluid from the sponge. Rub the sponge over the silk rapidly and evenly.

This process melts the film to the back of the screen, adhering it to the screen. When the film has dried for a few minutes, peel the backing from the film, leaving the area you want to print open. The film blocks out most of the silk. The seams around the edge of the screen are taped with masking tape to prevent ink from leaking through the edges of the frame. There may be space left on the screen where the film does not cover. Tape this open space with masking tape, or use fill-in green lacquer. The lacquer is usually poured on the surface and spread around with a piece of cardboard. Clear brushing lacquer may also be used. The lacquer can be used to blot out holes or breaks on the screen. When the lacquer is dry, the screen is ready to use.

Printing

Clamp the screen into position. The end opposite the clamps must have small pieces of cardboard or small pieces of a yardstick taped to the bottom corners of the frame to raise the screen about one-eighth inch off the table. When making a pass over the silk with the squeegee,

5.11 One hundred copies of this sign, measuring 3 feet by 4 feet, were screened on paper for a chain store.

5.12 This show card, 22 inches by 28 inches, was silk screened for a bank lobby.

5.13 This sign was screen printed on exterior masonite. It measures 4 feet by 8 feet.

this extra eighth of an inch gives the screen flexibility which allows the silk to snap up from the copy; this prevents the material being screened from sticking to the silk.

To print, pour the ink along the edge of the frame on the hinged side. The working consistency of the ink should be like warm butter. When you make a pass with the squeegee, press frimly and pull evenly. This steady pressure will give you an even print. You are actually squeezing the ink through the open silk to print.

Enamel-based inks are used in the lacquer gelatin film method of silk screen printing. Textile ink is used for printing on fabrics. Gloss enamel inks are used for printing on outdoor signs, including masonite and metal surfaces. Poster enamel is used for indoor signs on paper; poster board enamel based silk screen inks are thinned with oleum or mineral spirits. The oleum or mineral spirits are also used for cleaning up the screen after printing. The same screen may be used many times over if it is cleaned well after each use.

If you want to use an existing screen for different copy, wash the used copy out of the screen with lacquer thinner.

If you are unable to obtain silk screen supplies in your area, write to Rayco Paint Company, 2535 Laramie Avenue, Chicago, Ill. 60639. They carry a complete line of silk screen printing supplies.

Colonial and NAZ-DAR are companies that manufacture a complete line of silk screen inks.

Dick Blick Sign Supplies, Dept. B Box 1267, Galesburg, Ill. 61401, carries a complete line of silk screen printing supplies as well as sign painting supplies.

Section 6

Pictorial Painting
Billboards

Pictorial Painting

ALTHOUGH lettering is a semimechanical trade, the average sign person has considerable art ability. Pictorial work is a profitable outlet for this talent. Too many of us have a tendency to discourage the customer who wants a picture. This is all well and good when the patron expects you to paint a little masterpiece on a fifteen dollar show card. But there are many opportunities for us to encourage the idea of an illustrated sign. There are times when the customer would gladly pay fifty and sometimes a hundred dollars or more for just the right picture painted on a truck, window, or wall sign. This is the customer to be encouraged.

The old saying that one picture is worth a thousand words can be profitably demonstrated by the sign person. Usually, you can get a picture to work from or one to adapt for the purpose, and no great amount of originality is required.

If you do not have a projector for enlarging pictures, the old times-squared method is still very good. The stock pictures most used on signs are shown on the last pages of this book. It is also a good idea to collect all the good pictures you can from newspapers and magazines. File them away for use in the future. Such a collection is known as a "morgue."

Special brushes are not required for most pictorial work. On cards, the illustrations can be made in poster style with show card colors and regular red-sable brushes. Quick cartoons can be outlined with a small Speedball pen and waterproof ink, then colored with transparent watercolors.

When painting people in natural colors, it is important to get clean tones. Oil colors work best, and you should have a few tubes of artist's colors for mixing the proper tints and shades. Flesh tones are made from zinc white, yellow ochre, and a drop of vermillion or alizarin. The color is deepened with umber or terre verte for details (terre verte is a green). Paint the large masses of color first, then work over them with transparent shadows and white or tinted highlights.

Have the figures carefully sketched before you start. Do the overpainting with quick, sure strokes. If you paint a spot over and over, you will muddy the colors and lose the clean, snappy effect so much desired in this work. Shadows on flesh should look transparent

6.1 *Above left*, pictorial by the author, painted in enamels on a brick wall. Flat block out white was applied to the wall first as a primer. Bristle and soft-hair brushes were used.

6.2 *Above right*, the pictorial part of this sign, also by the author, was done in oils; the lettering and scroll work were done in enamels using quills and flat brushes. This work was painted on a smooth surface.

6.3 *Right*, the author painted the figure on this billboard in one color. This posterized type picture can be used effectively in all kinds of sign work.

rather than opaque. The vermillion, alizarin, and umber are much better for lips and other details than any of the regular sign writer's colors.

Four types of picture painting are used by the sign industry:
1. The graphic symbol, sometimes done impressionistically.
2. Posterized pictures done with solid colors and usually outlined.
3. The simple pictorial, usually done with one basic color with a highlight in white and shadowed with a dark color.
4. The high picture, which is blended well to give it a realistic look.

The graphic symbol and posterized, simple, and high pictorial all require different techniques.

Most pictorials in commercial shops are done with lettering enamel or bulletin colors. Use a lot of linseed oil to keep the paint from drying too quickly. You have to work fast to keep the paint from dragging on the brush or setting up before the picture is completed. Regular lettering brushes can be used.

A flat, white background is the best surface for pictorial painting. When picture painting on a truck or on precoated material, cover the area to be painted with blockout white, or dull the surface with 00 steel wool, or 400 superfine sandpaper.

To assure that the picture will hold up, varnish it with a good grade of clear varnish. Use a perfectly clear varnish or the white areas on the picture will turn yellow.

Extreme shadows and highlights are necessary to make the picture show up from a distance. Also, strong, brilliant colors should be used to assure clarity from a distance.

Objects (still life) such as bottles, cans, automobiles, and buildings are easier to paint than human figures. Faces are the most difficult and require discipline, study, and skill.

Linseed oil is used to thin the colors. Some pictorial artists use a rag saturated with linseed oil to wipe over the area they are painting. This makes the paint more workable on the surface of the board. Brushes used for outdoor pictorial work are fitches, cutters, and fillers. These brushes are pure bristle and are most appropriate for large pictorial work.

Billboards

Pictorial painting on billboards is completely different from commercial sign painting. The picture work is usually done by large, outdoor-advertising companies that hire picture painters. Picture painters are sign painters that have developed their pictorial skills. They are called high or deluxe pictorial painters.

There is a great difference in painting a picture on canvas 20 inches by 30 inches and doing a pictorial on a billboard 14 feet by 48 feet (illustrations 6.4 and 6.5).

In most cases, the artwork comes from an advertising agency. It usually comes as a scaled sketch, including the copy and a picture of the product being advertised. It can be an artistic rendering, color photograph, or a retouched photo.

6.4 Billboard pictorial, 14 by 48 feet, painted in oils by Eller Outdoor Advertising, St. Louis, Missouri.

6.5 Billboard pictorial, 14 by 48 feet, painted in oils by Tettaton Sign Company, St. Louis, Missouri.

The picture must be painted accurately to match the sketch. In the Introduction there is a picture of a Dewar White Label bottle and a Highlander painted in artist oils. In this case, a plot sketch was furnished with specifications, accompanied with color pictures of the bottle and the Highlander. The picture and copy were enlarged by an opaque projector, and full-size patterns were made on brown paper. The board is 14 feet high, with a 5 foot extension on the top and a 1 foot extension on the bottom, making the picture 20 feet high. The pounce pattern was perforated with an electric perforator. The pattern was pounced on the board and penciled in with an indelible pencil (or marking pen) to prevent the lines from being lost during the painting.

A great deal of skill and knowledge of blending and mixing colors is required for a professional job. The picture must appear authentic in every detail. Pictorial oil paints are used because of the color and true pigment they offer. Art supply stores, large department stores, and some paint stores carry artist oil colors in tubes. When a company is doing a lot of pictorial work, they order pictorial oils in pints and quarts straight from the factory. The Danacolor Company in San Francisco will sell direct to sign companies.

Section 7

Arrows
Constructing Squares and Rectangles
Enlarging and Reducing
Perspective

Arrows

Arrows have been used as a symbol for centuries. The human eye tends to follow the arrow, and for this reason, arrows are frequently used on signs to attract the viewer's attention to important words.

Illustration 7.1 shows several styles of arrows. As your lettering skill and experience increases, you will tend automatically to insert these attention-getting devices where they will be most effective. As a directional signal, they will serve to direct the eyes of the viewer to the message of the sign.

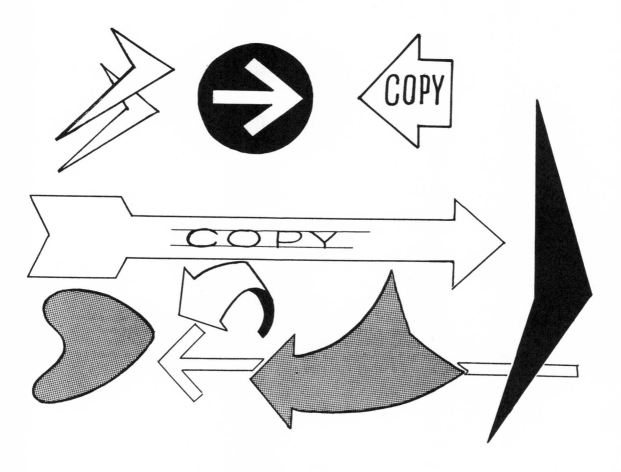

7.1 Arrows direct attention by creating a visual pathway.

Constructing Squares and Rectangles

It is frequently necessary to construct squares and rectangles on large surfaces where there are no convenient parallel reference lines. Large billboards, building sides, and roofs are often used for advertising signs. Use the following method for constructing squares or rectangles on these surfaces (see illustration 7.2):

1. Using a chalk line, snap a line on the desired slant.
2. With a small nail or tape, anchor a string on the line. Attach a pencil to the loose end of the string, and using this as a compass, strike arcs on the chalk line.
3. Move the nail to one intersecting point and, using a longer string, strike arcs above and below the line.
4. Repeat step 3, using the other intersecting point as base.
5. Connecting the two points where the arcs meet will form a line which is at right angles to the original line.
6. Repeating this process, a square or rectangle of any desired dimensions can be constructed.

Enlarging and Reducing

Proportional enlargement or reduction is fairly simple. See illustration 7.4 and follow these steps. First, draw a diagonal line through the original layout from the lower left-hand corner to the upper right-hand corner. Measure the diagonal of the area you wish to have in your finished work. Drawing in horizontal and vertical lines from that reference point will give you the dimensions of the final work. Or, if you know the new horizontal distance, measure that from the lower left-hand corner. Draw a vertical from that point, and use the place where the new right vertical intersects the diagonal to construct the new top of the sign.

For example: the layout size is 3¼ inches by 1¾ inches. You wish the new diagonal length to be 2⅝ inches. Constructing the new horizontal and vertical from the 2⅝ inch point on the diagonal gives you a proportional reduction which measures 2¹⁵/₁₆ inches by 1¼ inches.

Another example: your original is ¾ inch by ¹³/₃₂ inch. You wish to enlarge it so the horizontal length is 3¼ inches. Measuring the horizontal to that length and constructing a vertical from that point to the diagonal results in a proportional enlargement of 3¼ inches by 1¾ inches.

7.2 Constructing squares and rectangles.

7.3 Adding a slant to a sign area.

A completely different reduction method is to mark reference points on a stick held perpendicular to the baseline of the sign, as in illustration 7.5. Here, the borders and major copy lines have been transferred. By keeping the end on the original horizontal baseline and tilting the marker, the drawing will be proportionally reduced.

Still another method is to use a proportion wheel (illustration 7.6),

available at any graphics supply store. Take any known dimension and align that number (found on the inside wheel) with the desired dimension (found on the outside wheel).

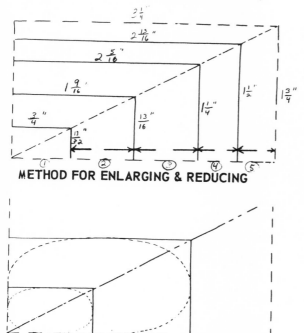

METHOD FOR ENLARGING & REDUCING

SAME LAYOUT FOR SMALLER SIGN

STICK PLACED ON LARGE SIGN VERTICALLY AND MARKED, THEN PLACED AS SHOWN, WILL REDUCE LAYOUT TO FIT SMALL BOARD

7.4 Reduction method using a diagonal line.

7.5 Reduction method using a stick.

7.6 Proportion wheel.

Now find the other known dimension on the inside wheel, and read its counterpart on the outside wheel. The proportion wheel will also tell you the percentage of enlargement or reduction you have effected. By knowing this, you can also know how to resize your letters to make the new layout completely proportional. For instance, if the new size is 50 percent of the old size and the letters on the original were 1 inch tall, the letters on the new layout should be ½ inch tall.

Perspective

Perspective is the most basic and most important factor in the effective visual presentation of any object. Yet, perspective drawing is extremely difficult to explain in readily understandable terms. Perhaps the best illustration of perspective which I can cite is the room in which you are now sitting. Look over into one corner. Note how the lines of the wall converge. Another good example is a railroad track. If you look down the length of the track, the rails seem to run together at a distant point, at which they disappear.

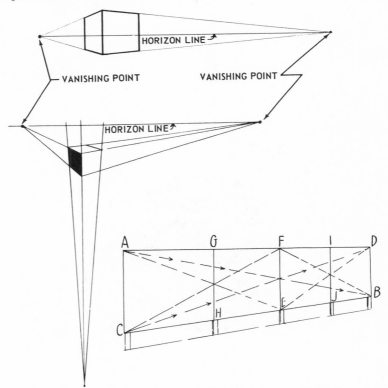

7.7 Perspective gives a realistic appearance to drawings.

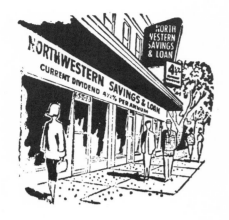

7.8 Everyday examples of perspective.

Section 8

Wood Cut-Out Letters
Routed Signs
Sandblasted Signs
Outdoor Super Graphics
Indoor Super Graphics
Sign Companies and What They Do

Wood Cut-Out Letters

ANYONE with the skill and knowledge to lay out letters can do well with wood cut-out letters. A band saw and a saber saw are used for cutting out wooden letters. A scroll saw is usually used for small, intricate letters.

Crezon and Duroply are ideal for most wood cut-out letters. When cutting out small letters with 1 inch or 2 inch depth, redwood is used. Masonite and plywood are not good materials for cut-out letters because they chip and split. After the letters are cut, they should be sanded and any holes filled with wood putty. Avoid sanding the face of the letters. It is important to seal the edge of the letters with primer before applying the primer and finishing coat of paint to the entire letter.

Letters can be painted with a mohair roller or spray painted for a fine finish. Letters for interior use are finished with flat or semi-gloss paint.

For interior or exterior use, the letters can be sprayed with lacquer. Lacquer will give the letters a rich sheen.

Letters can be attached to a wooden surface by screws. Countersink the screw heads and fill them with wood putty before applying paint or shellac. The letters can also be attached by applying contact cement to the back of the letters and nailing them with finishing nails, but be careful not to make hammer marks on the letters. Attach letters to brick or metal with silicone sealant.

Routed Signs

Routed signs are popular in parks and public places. They are used a great deal by ecology-minded people. There are many different effects you can achieve with the router, depending on the bit you use. The letters in routed signs are carved or engraved into the wood. The lettering can be laid out right on the wood with chalk, or a pattern can be made if you have several signs with the same copy.

Routers are becoming a popular power tool. They're easy to use and economical. See illustrations 8.2 and 8.3.

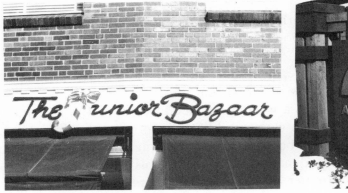

8.1 Four examples of wood cut-out letters, each used in a creative manner for business identification.

Sandblasted Signs

Wood sandblasted signs work well to depict a rustic, antique, Western, Old English, or Colonial look. The sandblasted sign gives the impression that the background of the letters was carved out, leaving the letters raised.

Pieces of wood for these plaques should measure 2 feet by 12 feet or larger, if you can obtain them. The boards are joined together with wooden pegs, and the seams are glued. Then the boards are clamped together. An accurate pattern of the layout should be made first. The pattern can be pounced on the board, and the letters stuck to it.

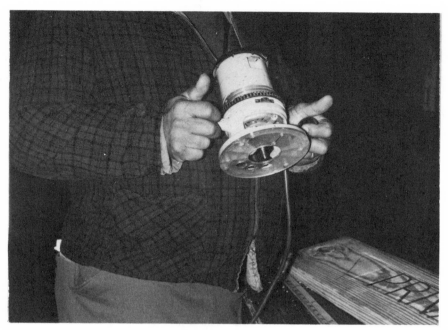

8.2 Copy is laid out on wood with chalk, charcoal, or pencil. Router may be adjusted to carving depth desired.

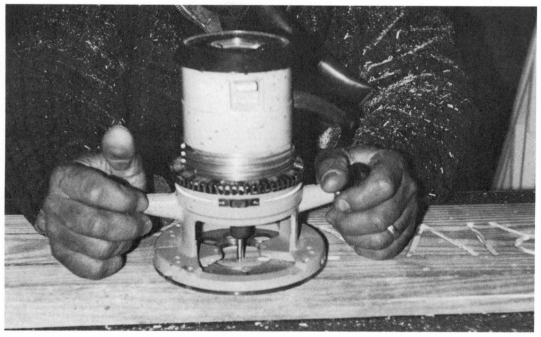

8.3 Router may be pushed and pulled over the letters as it carves.

Letters are cut from a flexible material with an adhesive back called "resist." Rubber from an old inner tube can also be used. The letters should be glued on with rubber cement so they can be peeled off easily. Then the sign is sandblasted. The rubber prevents the wood behind the letters from being blasted out. After the background has been removed to the desired depth, the rubber letters are peeled off. The letters appear raised from the background. The wood can be painted after it dries.

8.4 Sandblasted signs.

It would not be practical to invest in sandblasting equipment unless you do a large amount of this type of work. There probably are monument companies in your area that sandblast tombstones. If this technique provides the effect you want on an assignment, perhaps you can make arrangements for one of these companies to do the sandblasting for you.

Outdoor Super Graphics

Outdoor super graphics play a part in sprucing up the appearance of older cities. One place they are used is on large brick walls that are left after the buildings next to them have been torn down. These walls are first primed with a masonry primer; then a finish coat is applied. The art work is done with brilliant and harmonious colors. These graphics are pleasing and interesting to the public. See illustration 8.5.

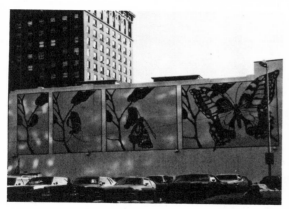

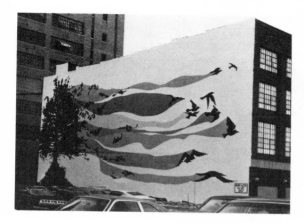

8.5 Outdoor super graphics.

Indoor Super Graphics

Indoor super graphics are used a great deal by businesses for functional decorating as well as advertising in a graphic manner. See illustration 8.6.

8.6 Indoor super graphics.

Sign Companies and What They Do

Derse Outdoor Advertising in Milwaukee is a company that started as a small commercial sign shop and is now the largest combination outdoor and commercial sign company in the city. Derse does painted bulletins primarily. They will, however, handle any type of sign: show cards, windows, cut-out letters, electrical signs, trucks, and walls.

Derse also operates a display manufacturing company that ships displays all over the United States. Illustration 8.7 shows examples of their work.

8.7 Examples of work by Derse Outdoor Advertising, Milwaukee, Wis.

Vollman advertising in Collinsville, Illinois, has grown from a small commercial sign shop to an advertising agency. They can produce a complete advertising package, including designing a new company logo, printing stationery and envelopes, and producing advertising pamphlets, advertising material, and artwork for newspaper ads.

In addition to handling on-premises signs and lettering trucks and company vehicles, Vollman can also furnish junior posters—outdoor painted units which rotate from location to location, city to city, every sixty days. Vollman's staff produces anything from corporate images to camera-ready artwork and 40 foot outdoor billboards. See illustration 8.8.

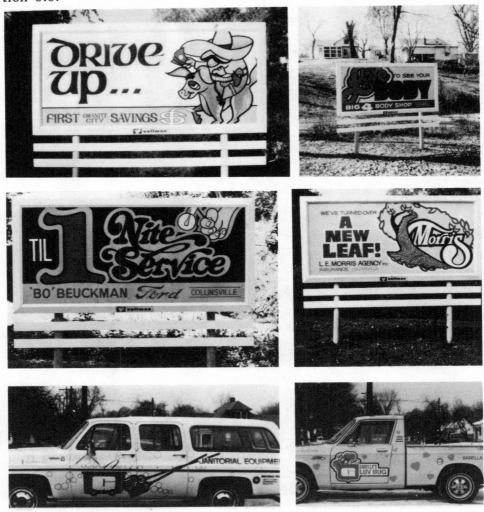

8.8 Examples of work by Vollman Advertising, Collinsville, Ill.

Kirn Sign Company of St. Louis, Missouri, furnished the photos of signs in illustration 8.9. Kirn started as a small commercial shop in 1902. Today they are an electrical shop, manufacturing neon illuminated plastic signs. These signs are examples of how illuminated plastic letters are handled.

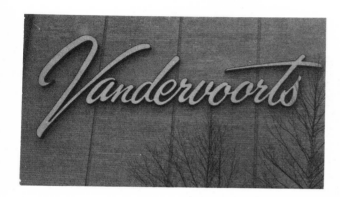

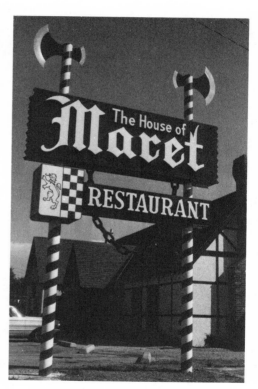

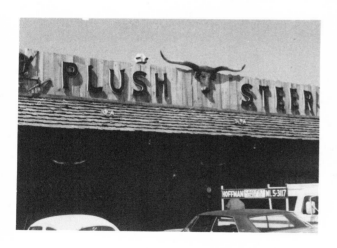

8.9 Examples of work by the Kirn Sign Company, St. Louis, Mo.

Tettaton Sign Company, after starting as a one-person shop in 1959, has grown to be one of the largest sign companies in the St. Louis area. Tettaton does outdoor advertising and all types of commercial sign work including wood cut-out letters and gold leaf. See illustration 8.10.

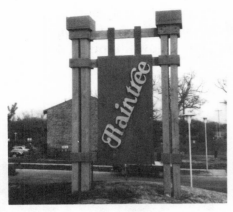

a. Wood cut-out letters mounted and painted.

b. Wood cut-out letters with gold Milor added.

c. Wood cut-out ram's head and horns mounted on a shield, gold-leafed letters.

d. Wood cut-out letters mounted and painted.

8.10 Examples of work by the Tettaton Sign Company, St. Louis, Mo.

8.11 Outdoor signs, each done on a different surface, utilize areas of structures.

Section 9

A Gallery of Signs
Layout Ideas
Designing Logos
Scrolls and Dingbats

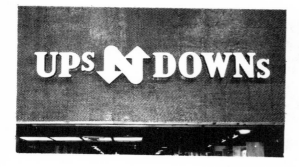

9.1 A gallery of signs (*cont.*).

9.1 A gallery of signs (*cont.*).

Layout Ideas

CHAIRS RENTED

The Coloradio Shop

 RESTAURANT

STERLING

AMERICAN RESTAURANT

FOR SALE

SANDWICHES

CANNONBALL

EMPIRE
CARPET CLEANING CO.

AUTO PAINTING

FRANK HOFMEISTER, St. Louis, Mo. Phone CE.1741 2603 N.11th ST. G.W. 10,000 B.L.

HARRY ATKINSON & SONS GENERAL HAULING 2513 MAIN ST.

 QUALITY DAIRY MILK

 Matson's NEW and USED FURNITURE 4416 EASTON AVE. Phone NE. 5061

 DAY and NIGHT AUTO SERVICE!

 BECKER ROOFING CO.

 More for Your FURNITURE WE PAY CASH

 HORN WELDING CO.

 F.W. STRECKER TRANSFER COMPANY

SIGNS

9.2 Layout ideas (*cont.*).

9.2 Layout ideas (*cont.*).

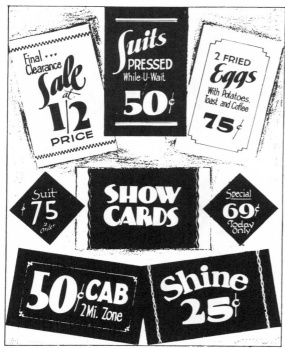

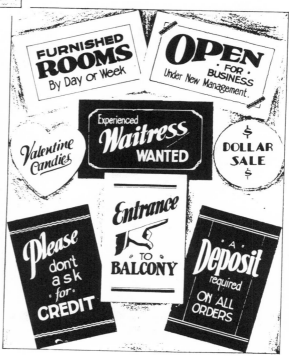

9.2 Layout ideas (*cont.*).

Galaxy

Roy
Mc Coy
OLDSMOBILE

Pert

FertiLife ™

Golde's

Kents

Tilleez

BOYD'S

9.2 Layout ideas (*cont.*).

jazz: BORN AGAIN

CHARO

Let the good times roll

neptune

DO IT NOW

insight

9.2 Layout ideas (*cont.*).

FRUIN-COLNON

SMUGGLER'S INN

WINE & DINE

Schneithorst's

The CHASE-PARK PLAZA

9.2 Layout ideas (*cont.*).

9.2 Layout ideas (*cont.*).

Designing Logos

Designing logos has become a part of the sign business. When you design a logo and make the sign, you should charge extra for the design. When a company goes to a graphics designer, art studio, or ad agency, they may pay three hundred to ten thousand dollars for a logo, depending on the caliber of the company and the designer.

9.3 Some examples of logos and symbols used in signs.

Logo designs usually are derived from the company's initials or a symbol of the product or service the company provides. The logo should be suitable for reproduction in many sizes for use on everything from business cards to product packages to billboards.

The company name is often worked into a graphic composition, as shown in illustrations 9.3, 9.4, and 9.5.

9.4 Logos by Vollman.

 Illinois State Bank
of East Alton

9.4 Logos by Vollman (*cont.*).

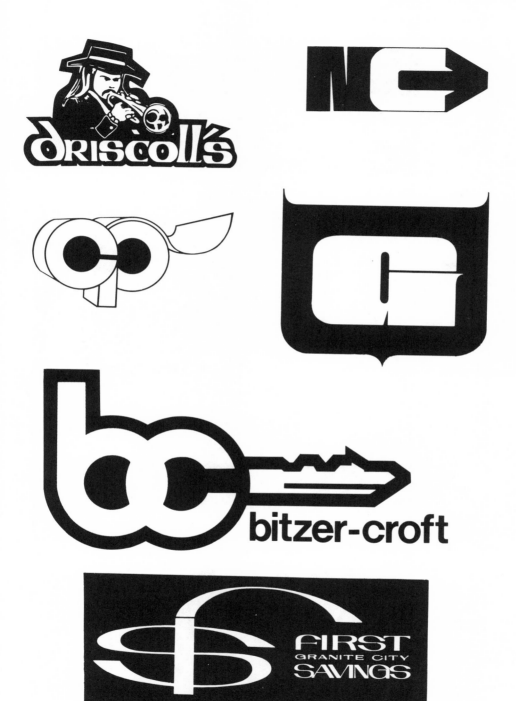

9.4 Logos by Vollman (*cont.*).

9.4 Logos by Vollman (*cont.*).

9.4 Logos by Vollman (*cont.*).

9.5 Logos by Tettaton.

9.5 Logos by Tettaton (*cont.*).

Scrolls and Dingbats

The term *dingbat* originated in the sign field. Dingbats were sign decorations popular in the 1920s and 1930s.

Scrolls are used in the same manner as dingbats. They are used in layouts to decorate borders and to accent important words in a sign, as well as to fill space.

When you want to achieve a nostalgic or ornate appearance in a sign, scrolls will be very helpful.

9.6 Scrolls and dingbats.

9.6 Scrolls and dingbats (*cont.*).

9.6 Scrolls and dingbats (*cont*.).

Handy Decorations and Space Fillers.

9.6 Scrolls and dingbats (*cont.*).

Section 10

Alphabets Designed by L. Tettaton
Modern Alphabets
Standard Alphabets
Nostalgic and Ornate Alphabets

Alphabets Designed by L. Tettaton

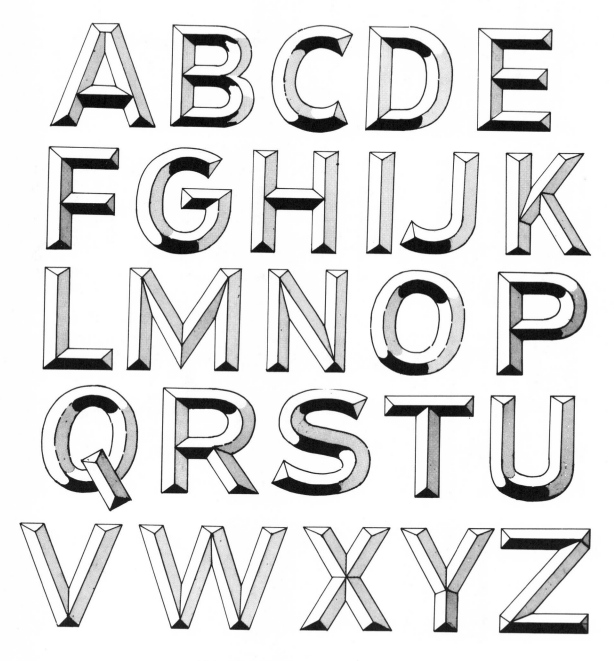

10.1 Three-shade convex alphabet.

ABCDEFG

HIJKLMNO

PQRSTUV

WXYZ

10.2 Clean convex alphabet.

ABCDEE
GHIJKLM
NOPQRST
UVWXYZf

10.3 Brush gas pipe alphabet.

ABCD
EFGHIJ
KLMNOP
QRSTUV
WXYZ

10.4 Wild spur alphabet.

ABCDEFG
HIJKLMN
OPQRSTU
VWXYZ 123
4567890?!

10.5　Brush Orient alphabet.

Modern Alphabets

Modern alphabets are used to depict up-to-date and futuristic moods in lettering.

ABCDEFGHIJKL
MNOPQRSTUV
WXYZ &?! .,
1234567889

10.6 Computer-type alphabet.

ABCDEFGHIJKLM
NOPQRSTUVWXY
Z. &?1234567890

10.7 Modern open alphabet.

abcdefghijklmnop

qrstuvwxyz ' •,

10.8 Circle lower-case alphabet.

abcdefghi
jklmnopqr
stuvwxyz
o d olen

10.9 Helvetica type lower-case alphabet.

ABCDEF
GHIJKL
MNOPQ
RSTUW
VXYZ ?;!
123456
7890
$&

10.10 Microgramma alphabet and numerals.

A B C D E F
G H I J K L
M N O P Q
R S T U V
W X Y Z

10.11 Venus heavy alphabet.

ABCDEFG
HIJKLMN
OPQRSTU
VWXYZ

10.12 Heavy thick-and-thin alphabet.

ABCDEFGHI
JKLMNOPQ
RSTUVW
XYZ

10.13 Custom scroll alphabet.

10.14 Open neon alphabet.

10.15 Modern neon alphabet.

ABCDEFGHIJK
LMN OPQRST
UVWXYZ

10.16 Spike alphabet.

ABCDEFGHI
JKLMNOP
QRSTUVW
XYZ

10.17 Spike loop alphabet.

ABCDEFGHIJK
LMNOPQRST
UVWXYZ ?

10.18 Flat-top bold alphabet.

ABCDEFGHIJKLM
NOPQRSTUVWXYZ
abcdefghijklmnop
rstuvwxyz

10.19 Milk bottle alphabet.

ABCDEFG
HIJKLMNO
PQRSTUV
WXYZ abcdfeg
hijklmnopqrstuvwxyz

10.20 Brush script alphabet.

D ABCDEFG
E HIJKLMN
Q OPQRSTT
R UVWXYZ

abcdefghijklmnoprstuvwxyz

10.21 Brush script narrow alphabet.

183

ABCDEFGHIJ
KLMNOPQRST
UVWXYZabcdefg
hijklmnopqrstuvwxyz

10.22 Brush script wide alphabet.

ABCDEFG
HIJKLM
NOPQRST
UVWXYZabc
abcdefghijklmnopqrstuvwxyz

10.23 Brush script alphabet.

Standard Alphabets

ABCDEFGHIJK
LMNOPQRSTU
VWXYZ&

10.24 Broadway alphabet.

ABCDEFGHIJ
KLMNOPQRS
TUVWXYZab
cdefghijklmno
pqrstuvwxyz

10.25 Cooper bold alphabet.

ABCDEFGHI
JKLMNOPQ
RSTUVW
XYZ abcdef
ghijklmnop
qrstuvwxyz

10.26 Light face thick-and-thin alphabet.

ABCDEF
GHIJJKM
LMNOPQ!
RSTUUVW
XYZESR&
abcdefghij
jkklmnopqr
sttuvwxyz~

10.27 Show card alphabet no. 1.

ABCDEFG
HIJKLMN
OPQRSTU
VWXYZ&
dbcdefgh
ijklmnopq
rstuvwxyz
123456789

10.28 Show card alphabet no. 2.

ABCDEFG
HIJKLMMN
OPQRSTU
VWXYZ&
abcdeffgh
ijklmnopqr
sttuvvwxyz!

10.29 Show card alphabet no. 3.

Modern
freak

ABCDEFGH
IJKLMNOP
QRSTUVWX
YZ & & And
abcdefghijk
lmnopqrstu
vwxyz

10.30 Show card alphabet no. 4.

ABCDEFGHI
JKLMNOPQ
RSTUVWXYZ
$1234567890¢

abcdefghij
klmnopqrs
tuvwxyz &

10.31 Show card alphabet no. 5.

ABCDEF
GHIJKL!
MNOPQR
QRSTUW
VWXYZ 25
abcdefghijkl
mnopqrstuw
xyz &&'?

10.32 Show card alphabet no. 6.

ABCDEFGH
IJKLMNOPQ
RSTUV
WXYZ!
abcdefghijk
lmnopqr
stuvwxyz

10.33 Show card alphabet no. 7.

ABCDEFG
HIJKLMNO
PQRSTUV
WXYZ &'&
abcdefgghijklm
nopqrstuv
wxyz!

10.34 Show card alphabet no. 8.

10.35 New York Roman alphabet and numerals.

ABCDEFGHIJKLM
NOPQRSTUVWXYZ
QRST567890

10.36 Flat-top alphabet, with variation and numerals.

ABCDEFGHI
JKLMNOPQR
STUVWXYZ&

10.37 Flat-top bold alphabet.

ABCDEFGHIJ
KLMNOPQRST

10.38 Flat-top spur alphabet (incomplete).

10.39 Bulletin Roman alphabet.

10.40 Modern gas pipe alphabet and numerals.

10.41 Light face round block alphabet with variation.

ABCDEFGHIJK
LMNMNOPQRS
TUVWXYZ̃Z&

abcdefghijklm
nopqrstuvwxyz

1234567890

10.42 Simple Roman alphabet and numerals.

10.43 Thick-and-thin full block alphabet.

10.44 Big top alphabet.

1234 56789

123456789

123456789

123456789

123456789

123456 789

1234567890

10.45 Numerals.

ABCDEFGHI
JKLMNOP
QRSTUVW
XYZ

abcdefghijk
lmnopqrs
tuvwxyz

abcdefg opqrst

10.46 Modern script.

10.47 Script in italic style, with numerals.

10.48 Script in italic style.

10.49 Script in italic style.

10.50 Script in italic style.

ABCDEFG
HIIJKLMN
OPQRST
UVWXYZ

10.51 Card round block alphabet.

abcdefghi
jklmnopq
rstuvwxyz

10.52 Heavy script alphabet, lower case.

10.53 Boxcar alphabet, with numerals.

10.54 Expanded boxcar spur alphabet.

ABCDEFGHIJKLM
NOPQRSTUVWXYZ
abcdefghijklmnopqrs
tuvwxyz1234567890

10.55 Modern block alphabet with numerals.

ABCDEF
GHIJKL
MNOPQ
RTUVW
S XYZ & S

10.56 Tuscan style alphabet.

ABCDEFG
HIJKLMNO
PQRSTU
VWXYZ
123456789

10.57 Plain stencil alphabet with numerals.

10.58 Condensed stencil alphabet with numerals.

10.59 Round show card alphabet.

ABCDEFG
HIJKLMN
OPQRSTU
VWXYZ&

abcdefghijk
lmnopqrstu
vwxyz TUSCAN

10.60 Brush Tuscan alphabet.

ABCDEFGH
IJKLMNOP
QRSTUVW
XYZ 12345 &
67890

10.61 Bold show card alphabet and numerals.

ABCDEFG
HIJKLMN
PQRSTU
VWXYZ&

10.62 Stencil bold alphabet.

ABCDEFGH
IJKLMNOP
QRSTUVWX
Y&Z

abcdefghijk
lmnopqrstu
vwxyz

10.63 Modern bold alphabet.

ABCDEFGHIJKLMN
OPQRSTUVWXYZ&$
1234567890.,'-:!?
abcdefghijklmn
opqrstuvwxyz

10.64 Broadway series: alphabet no. 1 with numerals.

ABCDEFGHIJKLMNOP
QRSTUVWXYZ&$
1234567890:;-!?
BROADWAY SERIES

10.65 Broadway series: alphabet no. 2 with numerals.

ABCDEFGHIJKL
MNOPQRSTUVW
XYZ

10.66 Broadway series: alphabet no. 3.

abcdefghijk
lmnop
qrstuvwxyz

10.67 Text lower-case alphabet.

ABCDEFGHIJ
KLMNOPQRS
TUVWXYZ &

10.68 Roman italics alphabet.

10.69 Western alphabet.

ABCDEFGHI
JKLMNOPQRST
UVWXYZ&

10.70 Condensed Gothic alphabet.

Sign SISCO

beauty

GRUMBACHER

LUMITONE

10.71 Varieties of condensed Gothic.

ABCDEFG
HIJKLMN
OPQRSTU
VWXYZ&
1234567
89ЄR

10.72 Convex spur alphabet and numerals.

Nostalgic and Ornate Alphabets

ABCDEFGHIJ
KLMNOPQR
STUVWXYZ&

10.73 Rustic Roman alphabet.

ABCDEF
GHIJKM
LNQPRT
SUVWX
YYZ&&

10.74 Fancy Tuscan alphabet.

10.75 Ornate fancy Tuscan alphabet.

10.76 Tuscan script alphabet.

ABCDEFGHIJKLMNOPQRSTUVWXYZ
abcdefghhijklmnopqrstuauvwxyz

10.77 Roman flair alphabet.

ABCDEFG
HIJKLMN
OPQRSTU
VWXYZ

10.78 Wing alphabet.

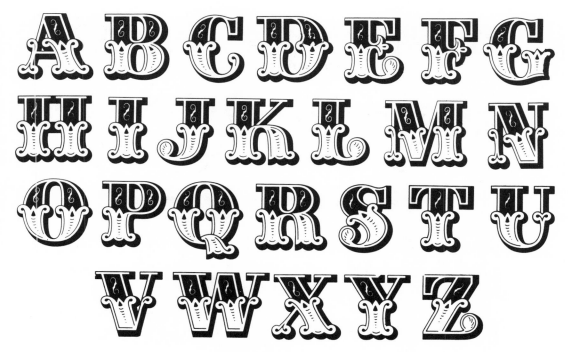

10.79 Ornate Barnum alphabet.

10.80 Modified Roman outline alphabet.

10.81 Modified Roman solid alphabet.

ABCDEFGHIJK
LMNOPQRSTU
VWXYZ
abcdefghijklmn
opqrstuvwxyz

10.82 Old English alphabet.

ABCDEFGHIJK
LMNOPQRSTU
VWXYZ a abcdefghijkl
mnopqrstuvwxyyz

10.83 Modified Old English alphabet.

10.84 Spencerian script alphabet.

ABCDEFGHIJK
LMNOPQRSTU
VWXYZ&?
1234567890$;!

10.85 Ornate block alphabet and numerals.

ABCDEFGHIJKLM
NOPQRSTUVWXYZ
$1234567890
&?!,

10.86 Condensed showbill alphabet and numerals.

Index

General Index

Index A—Paints, Shellacs, Thinners

Index B—Brushes

Index C—Materials and Tools

Index D—Types of Signs, Sign Materials

Index E—Gilding Terms

Index F—Styles of Lettering